Mandalas: Color Your Dreams

Susan Apurado

All rights reserved. Copyright © April 2017/ Susan Apurado.

No part of this publication may be reproduced,

distributed, or transmitted, in any form or by any means, including

photocopying, recording, or other electronic or mechanical methods,

without prior written permission of the publisher, except for brief

quotations for reviews and certain other non-commercial use permitted

by the copyright law.

Any person or persons who do unauthorized act in relation to this

publication may be liable to criminal prosecution and civil claims

of damages.

ISBN -13: 978-1544908304

ISBN-10: 154490830X

First Printed by Createspace, May 2017

United States of America

Introduction

The following pages are 50 beautiful Mandalas which were artistically designed just for you.

When life becomes relatively blurry, we need to adjust the lens of our hearts and minds in order to get a clearer vision, and be able to get ready to color our life's dreams.

Dream. Whatever it is, even the simplest one is substantial. Have a great time coloring!

Breathe, relax, and be happy.

Susan Apurado

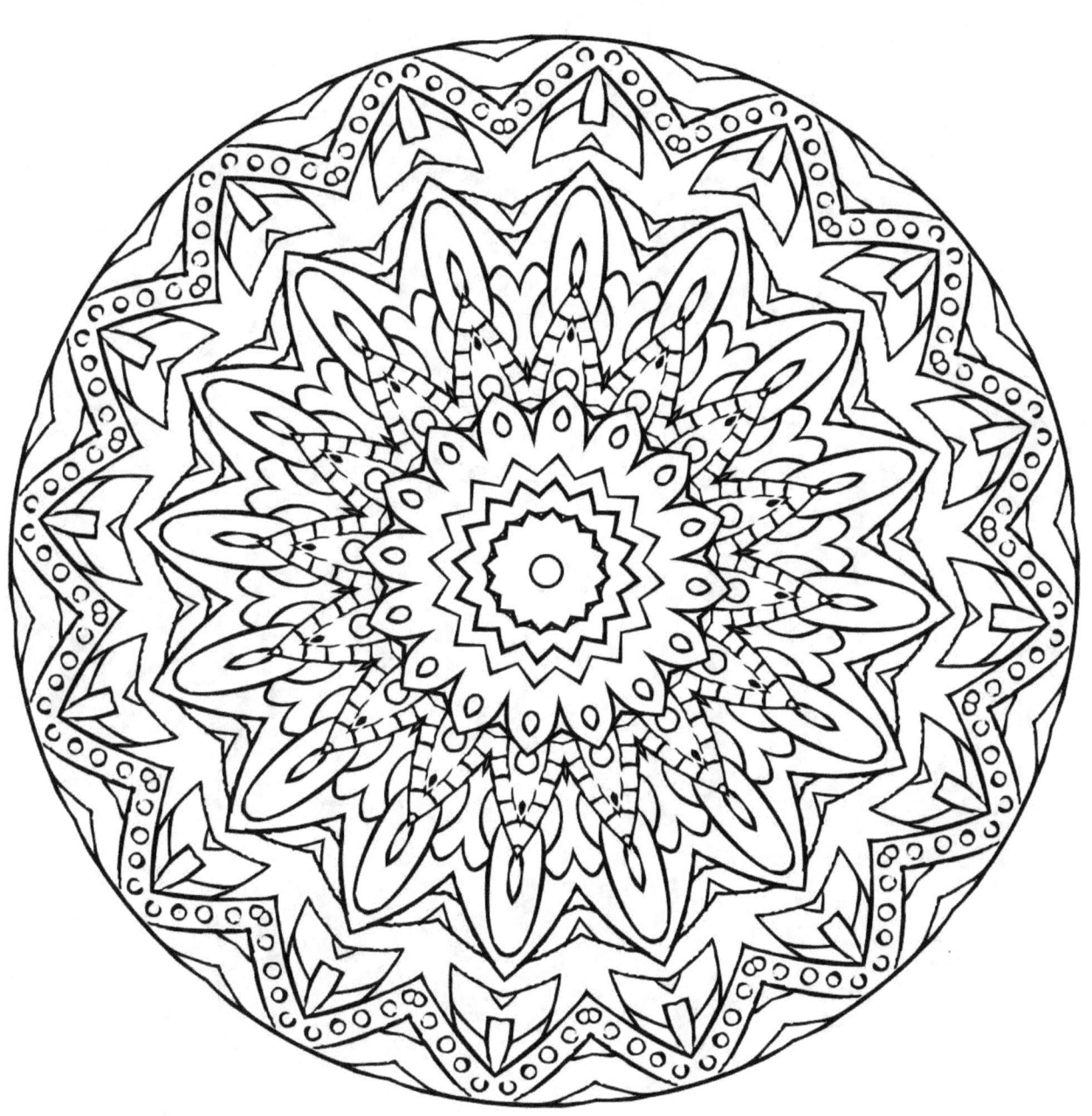

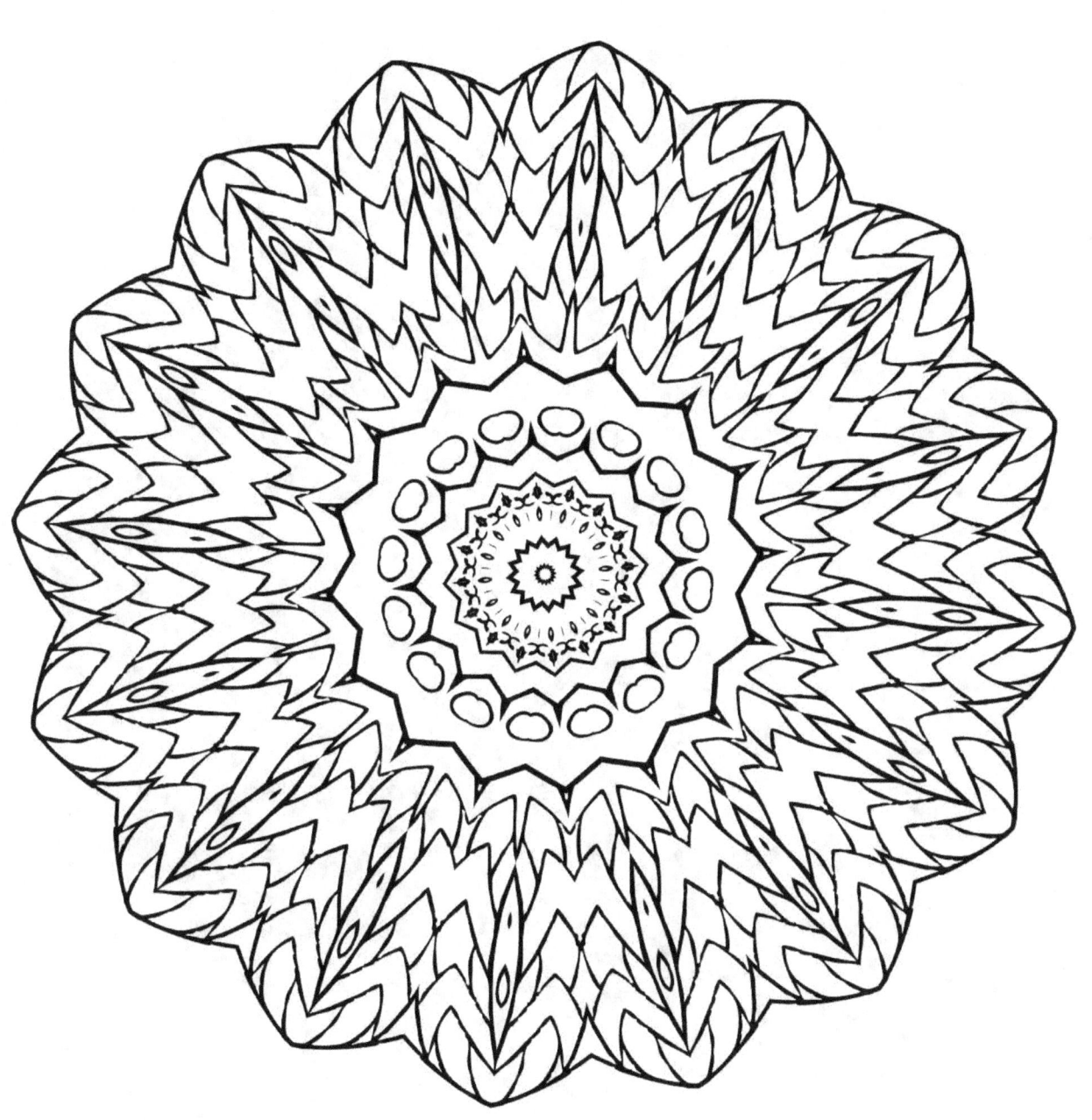

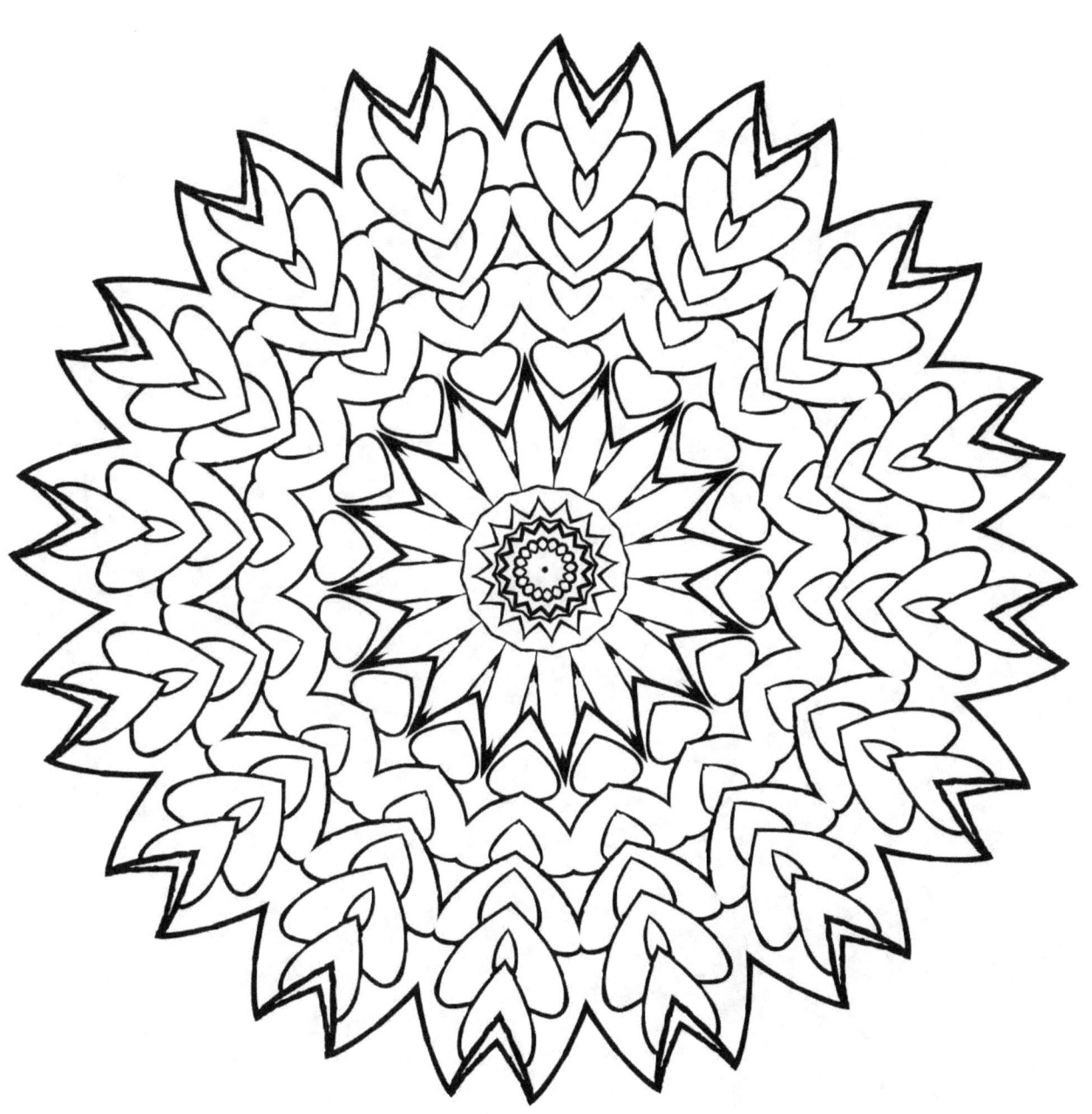

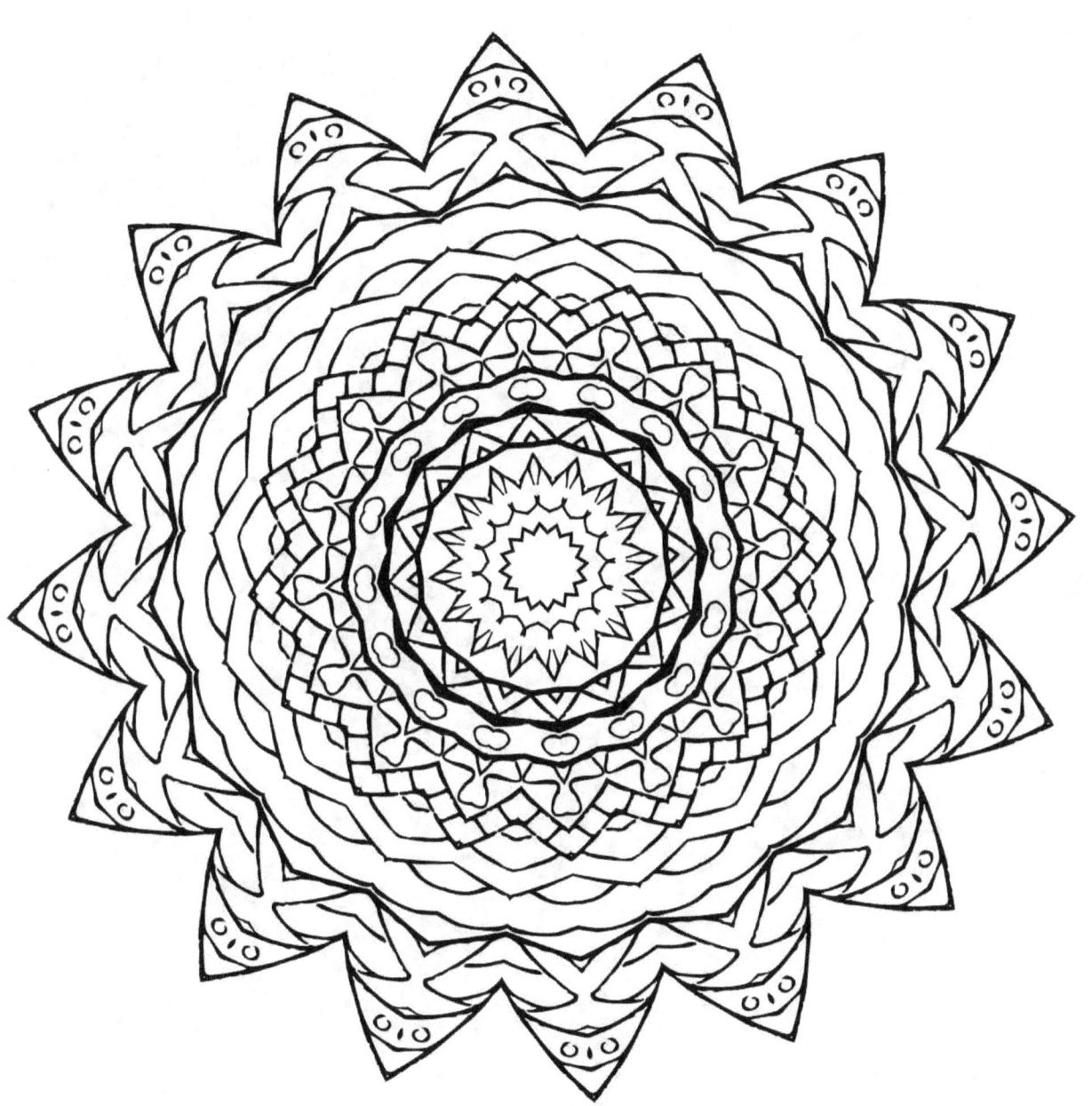

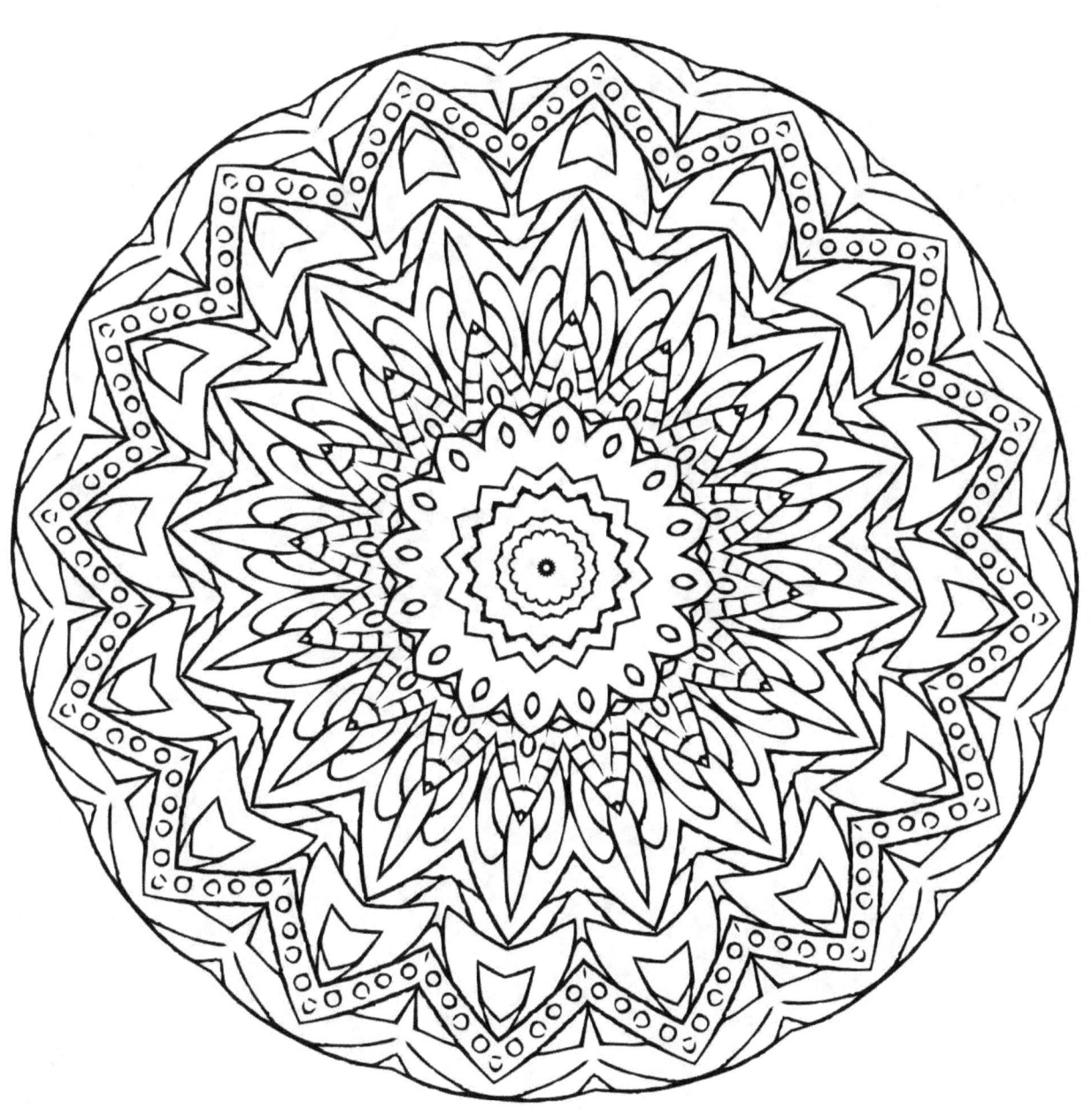

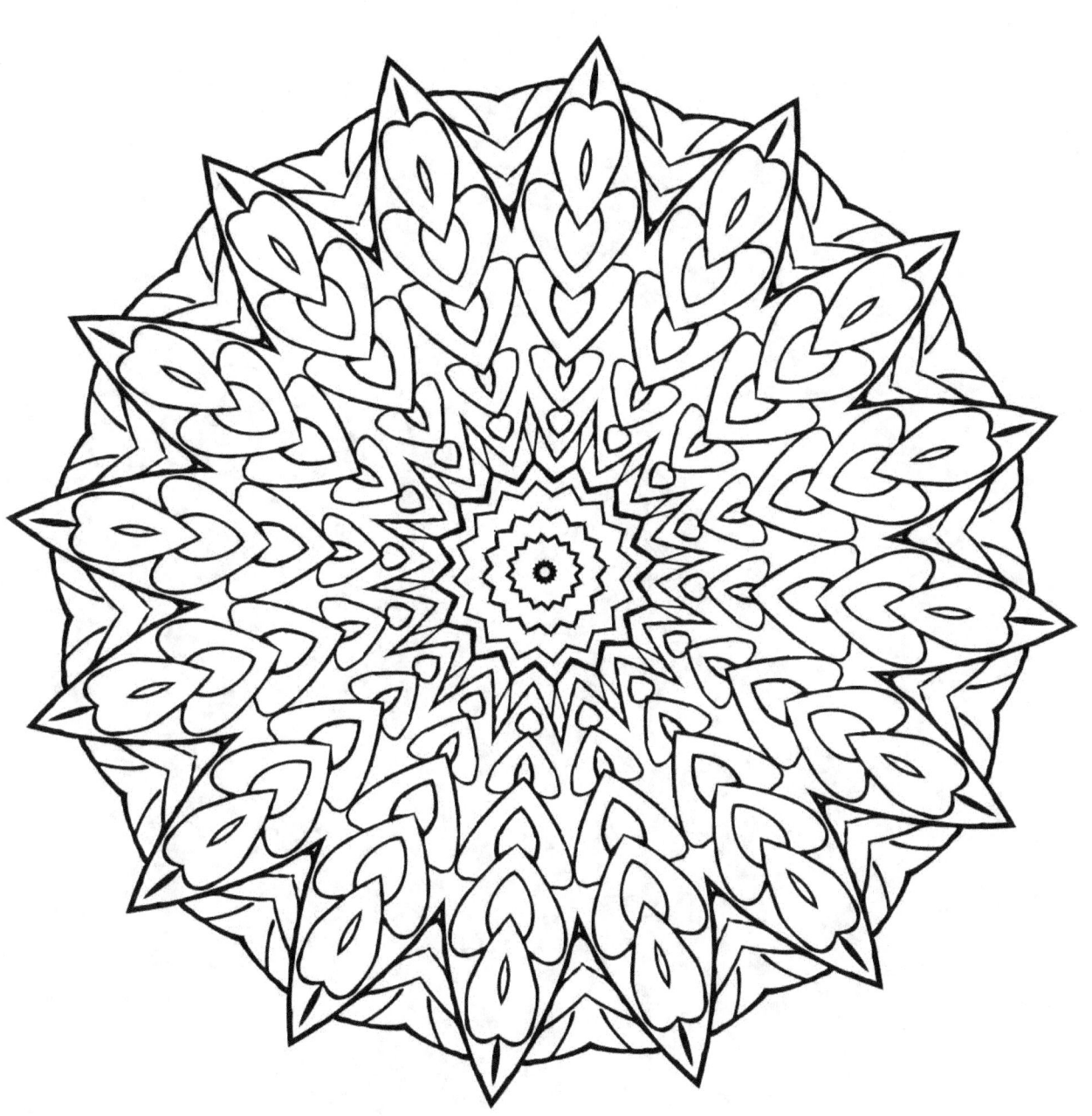

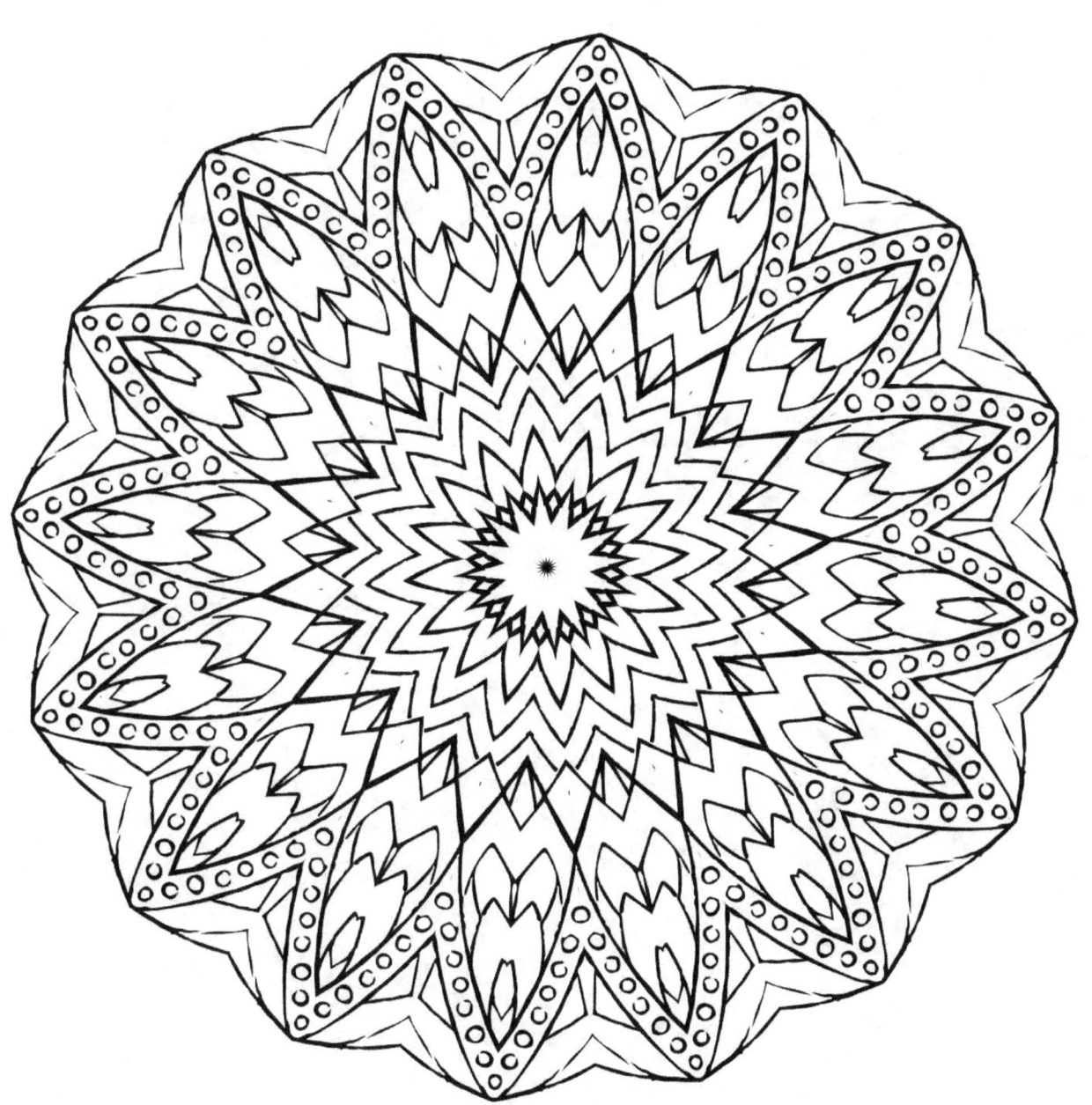

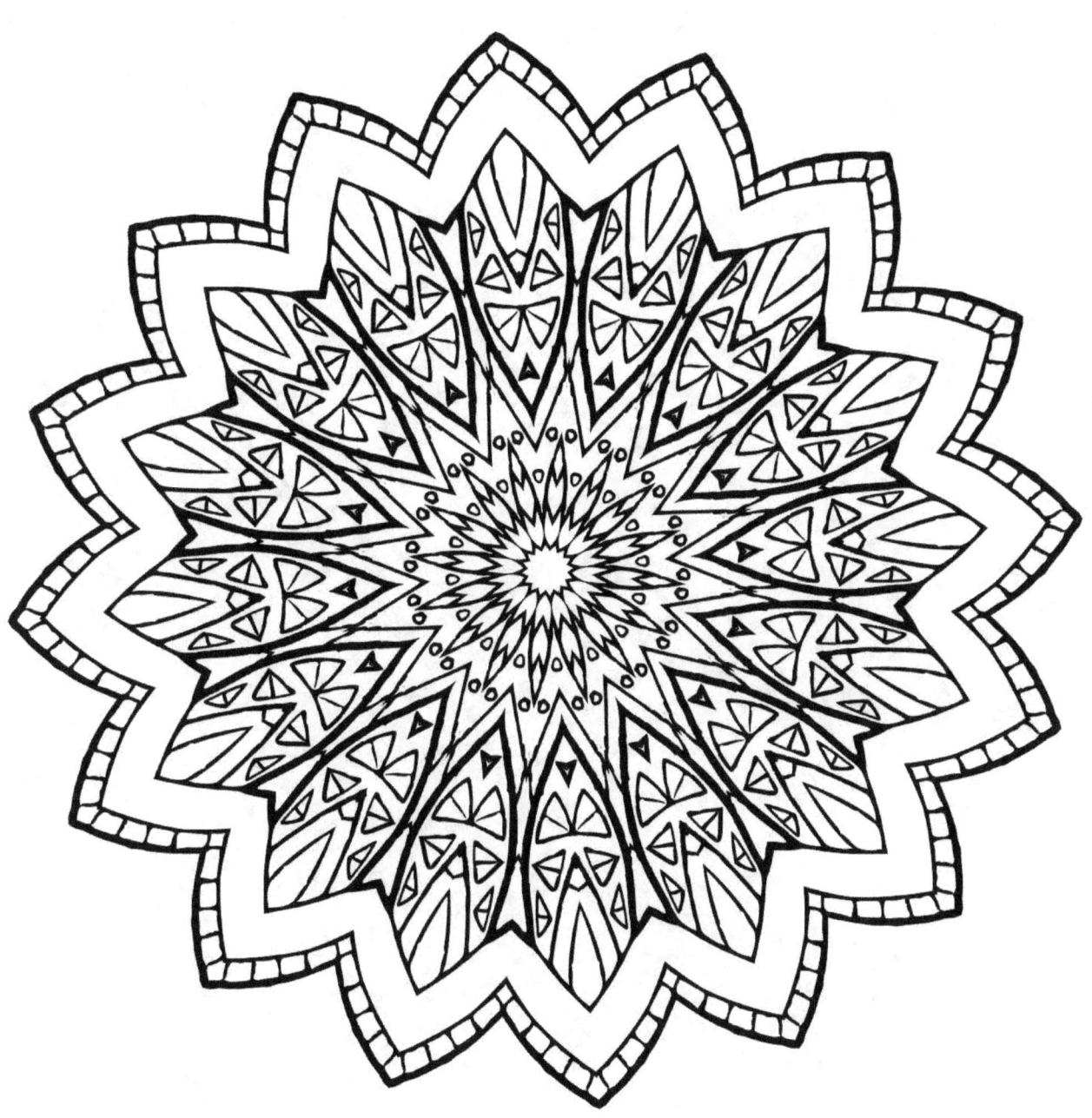

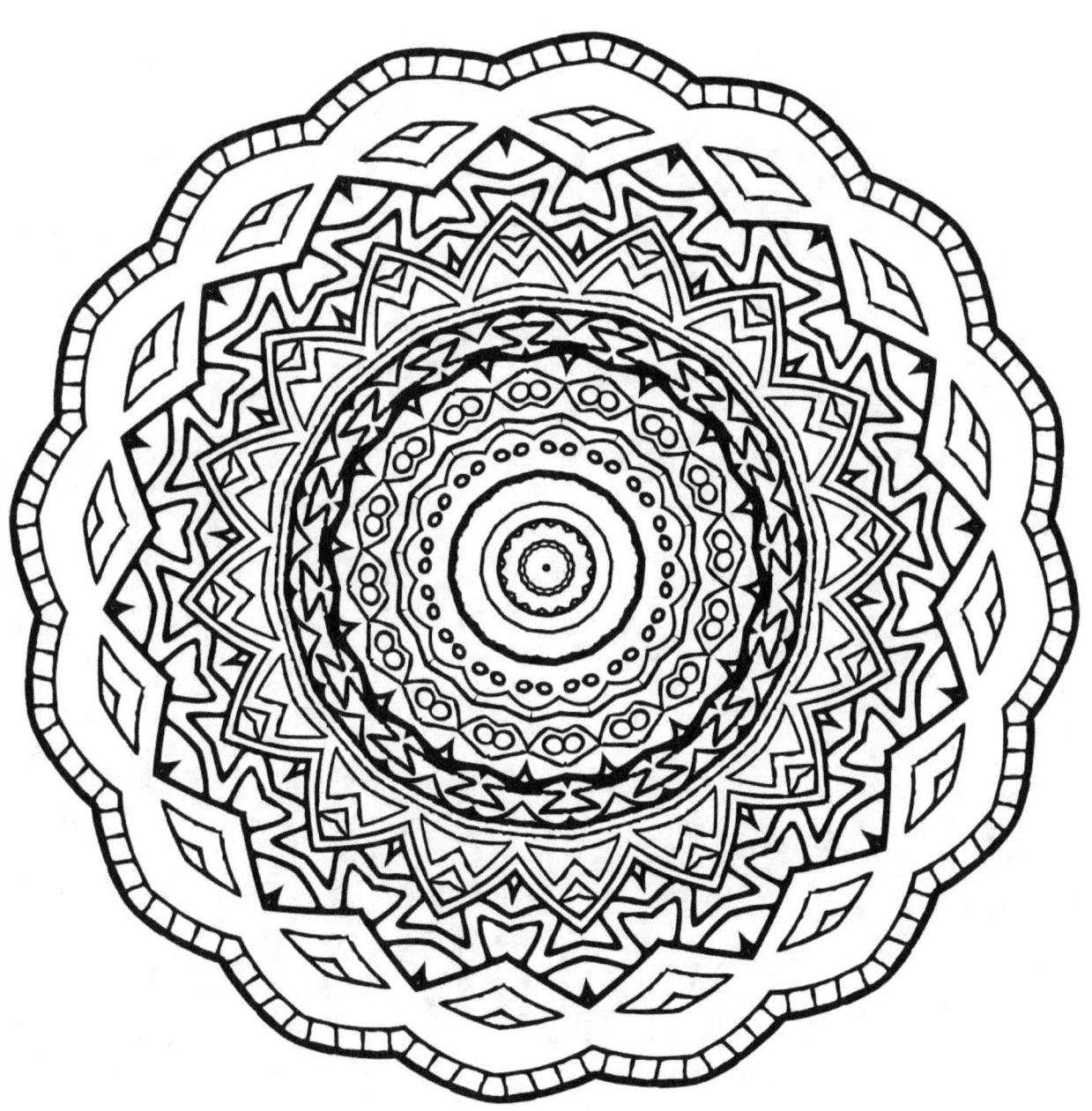

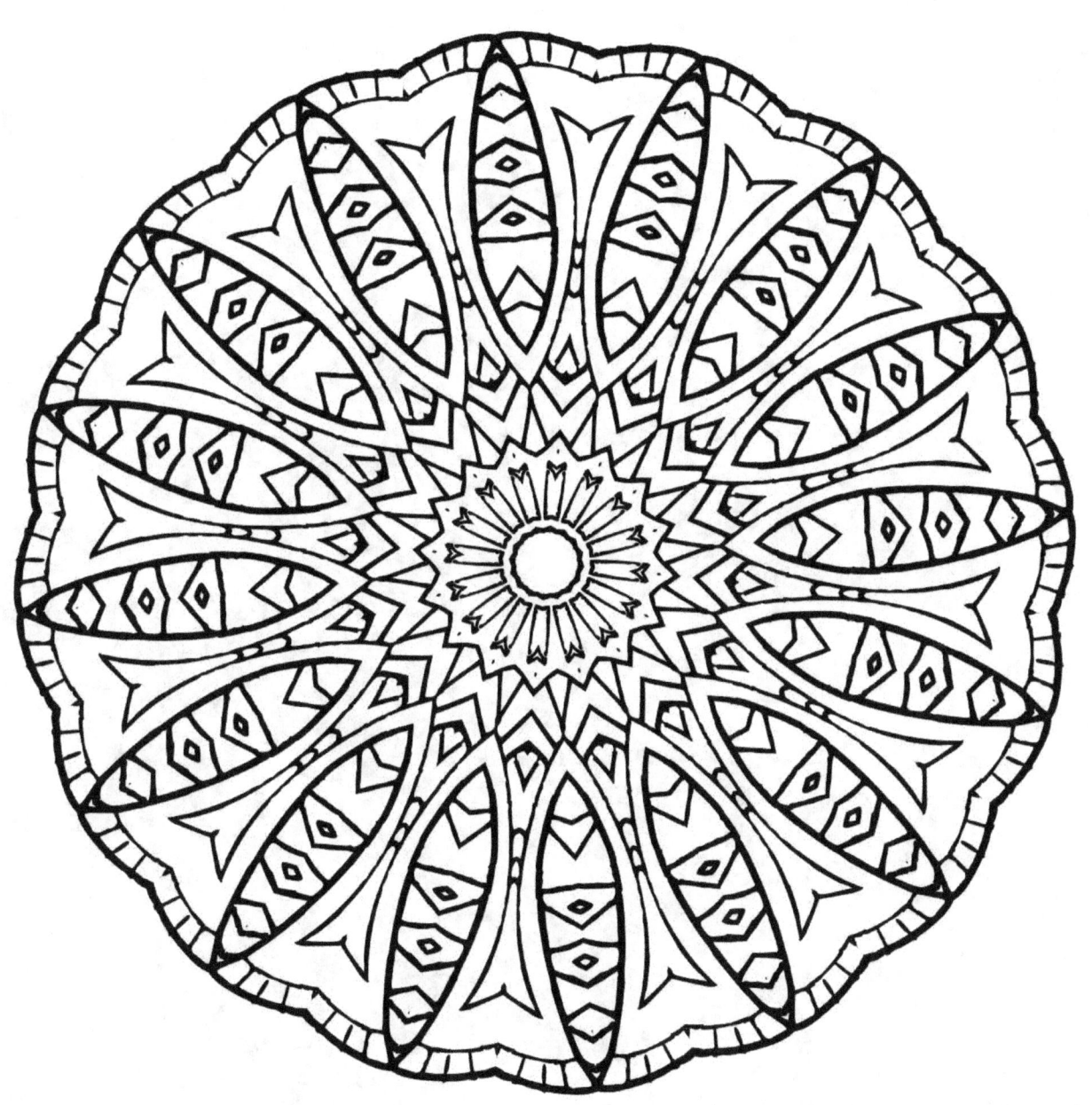

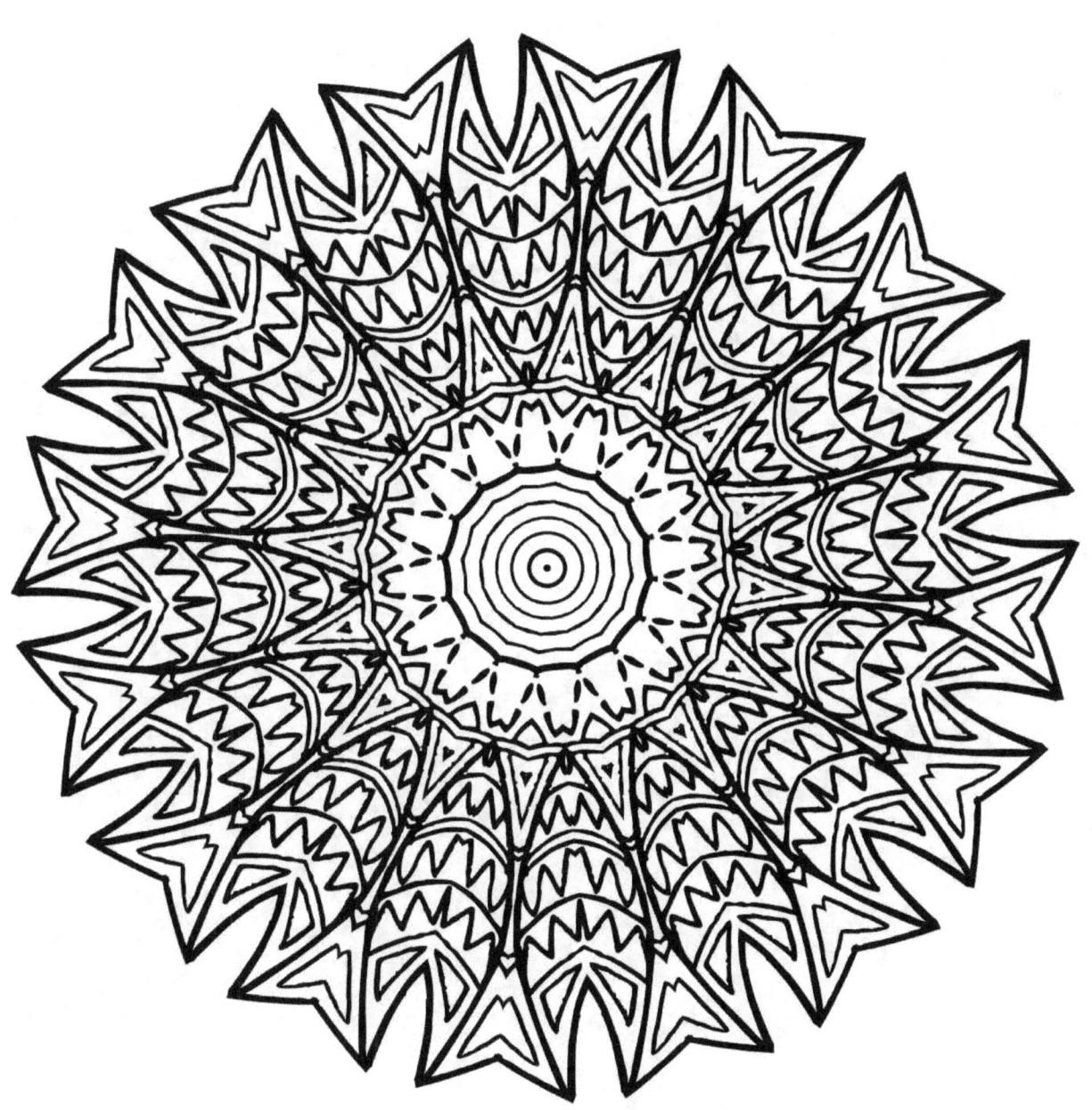

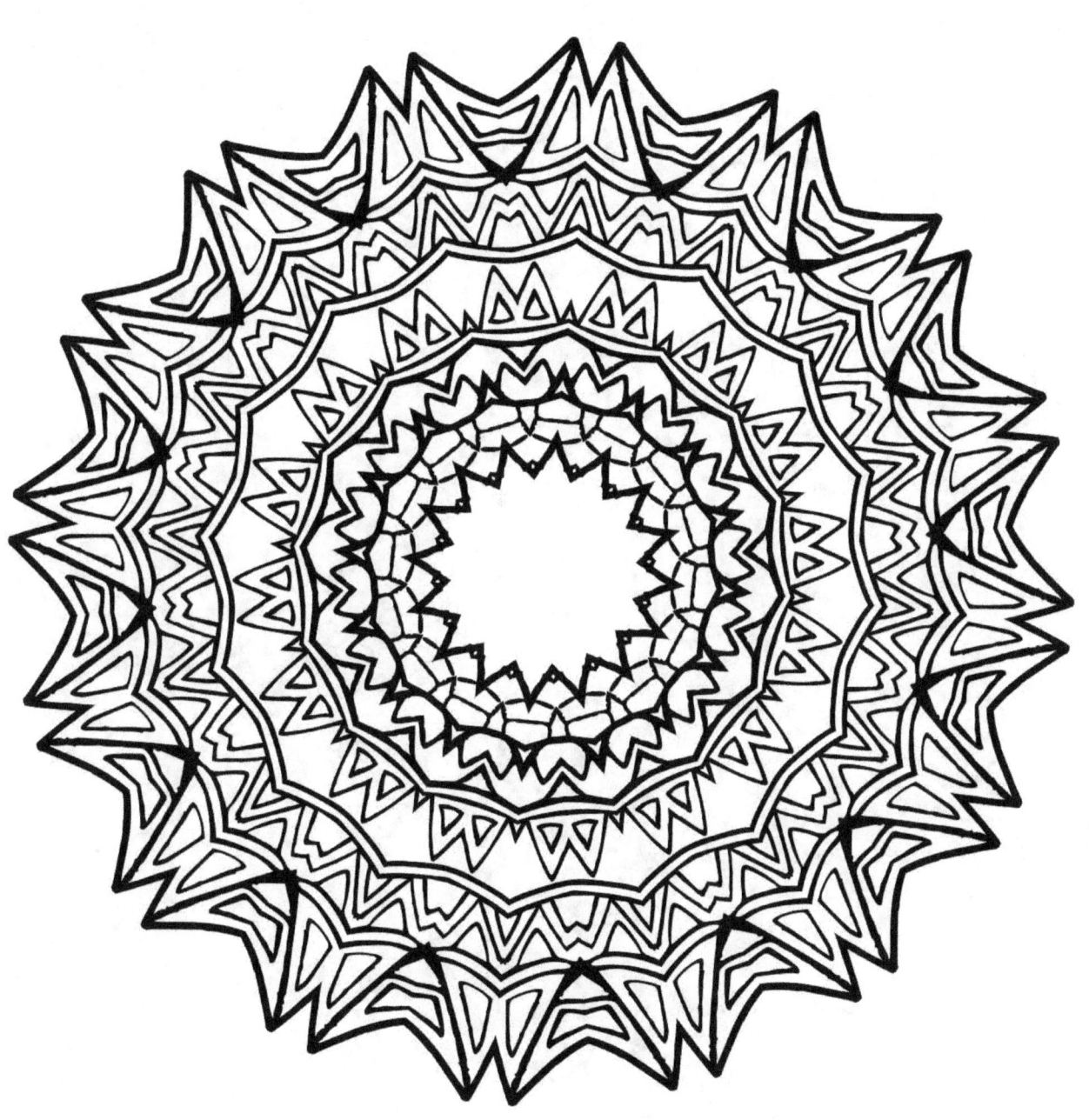

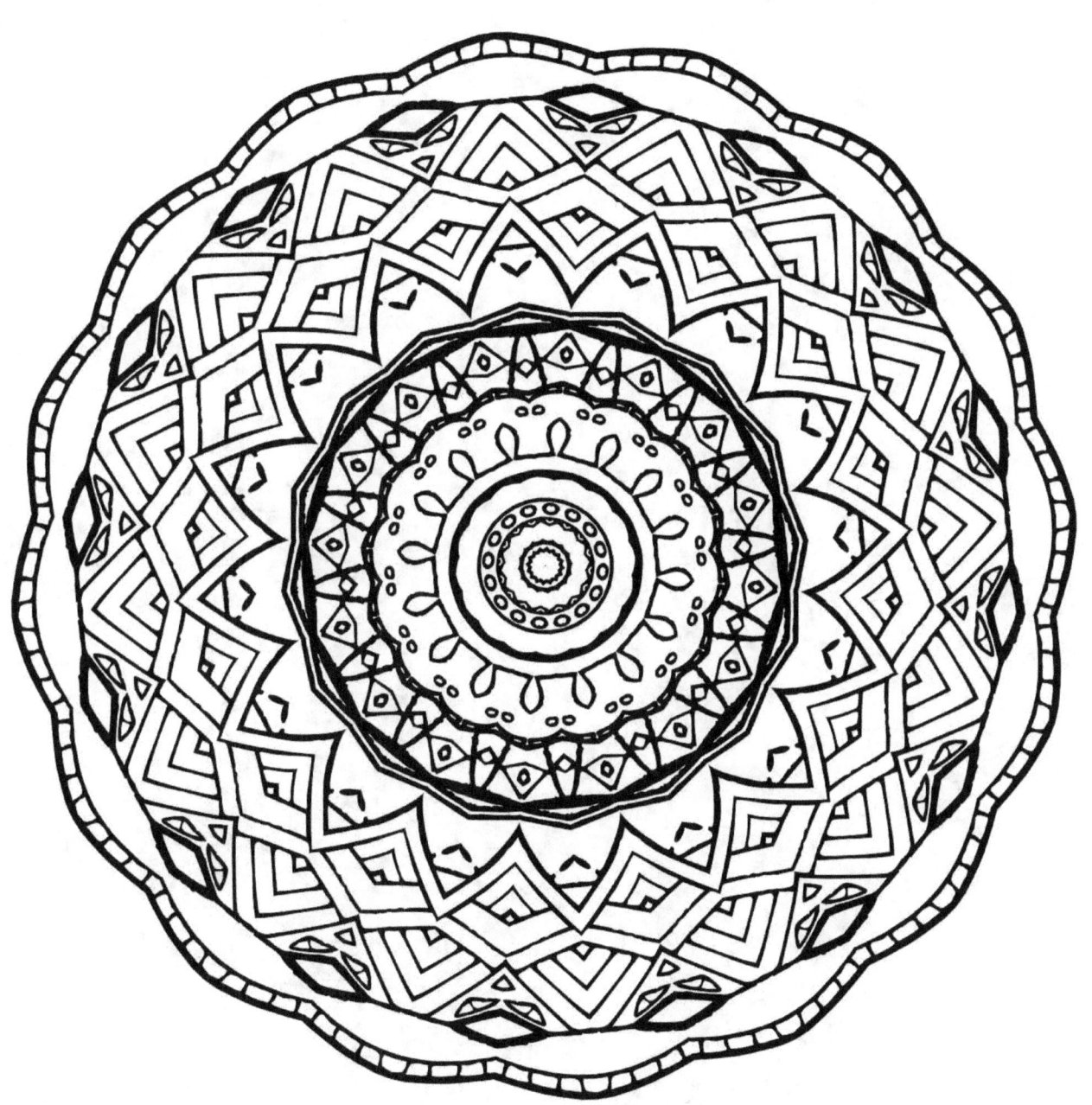

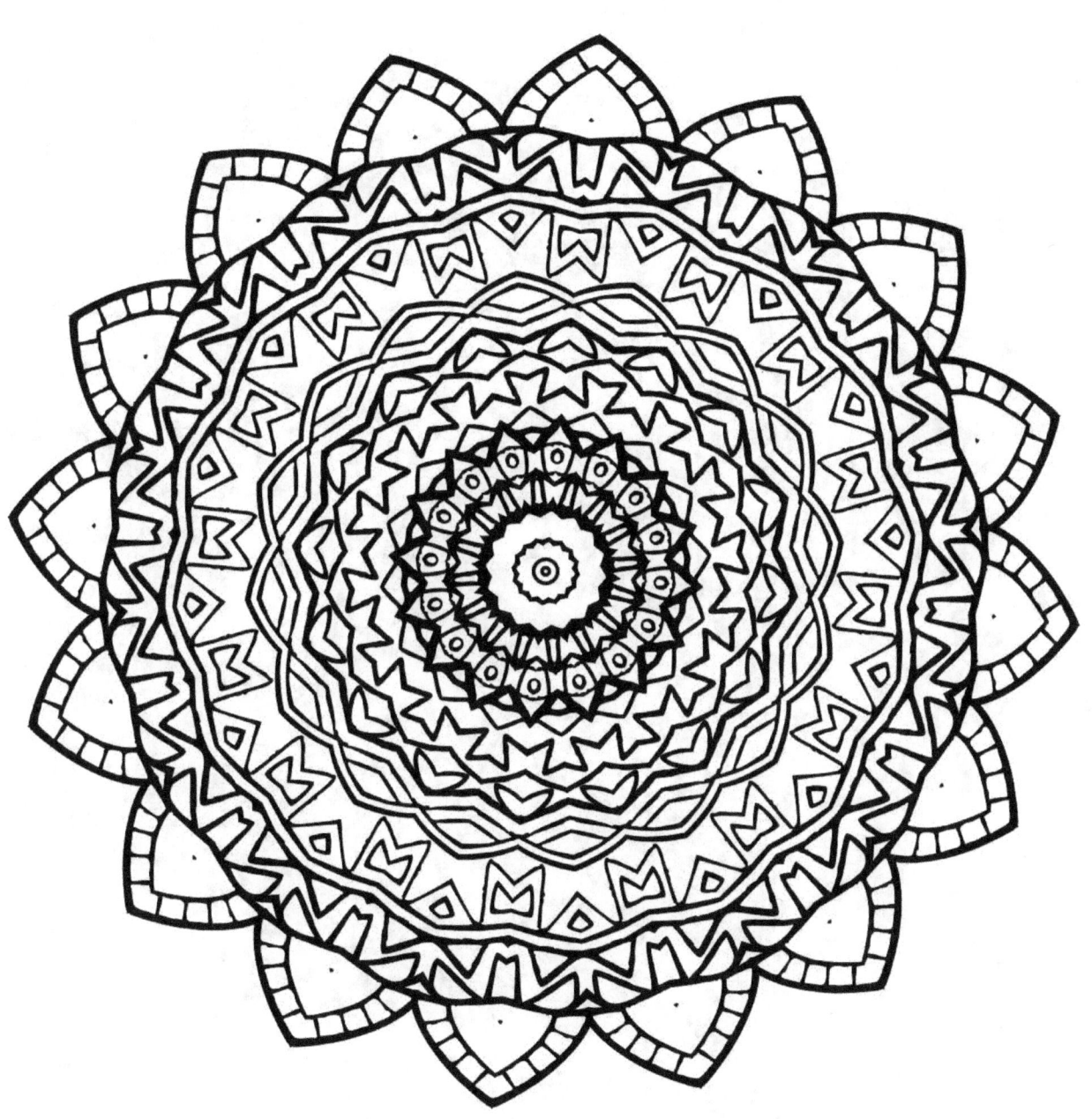

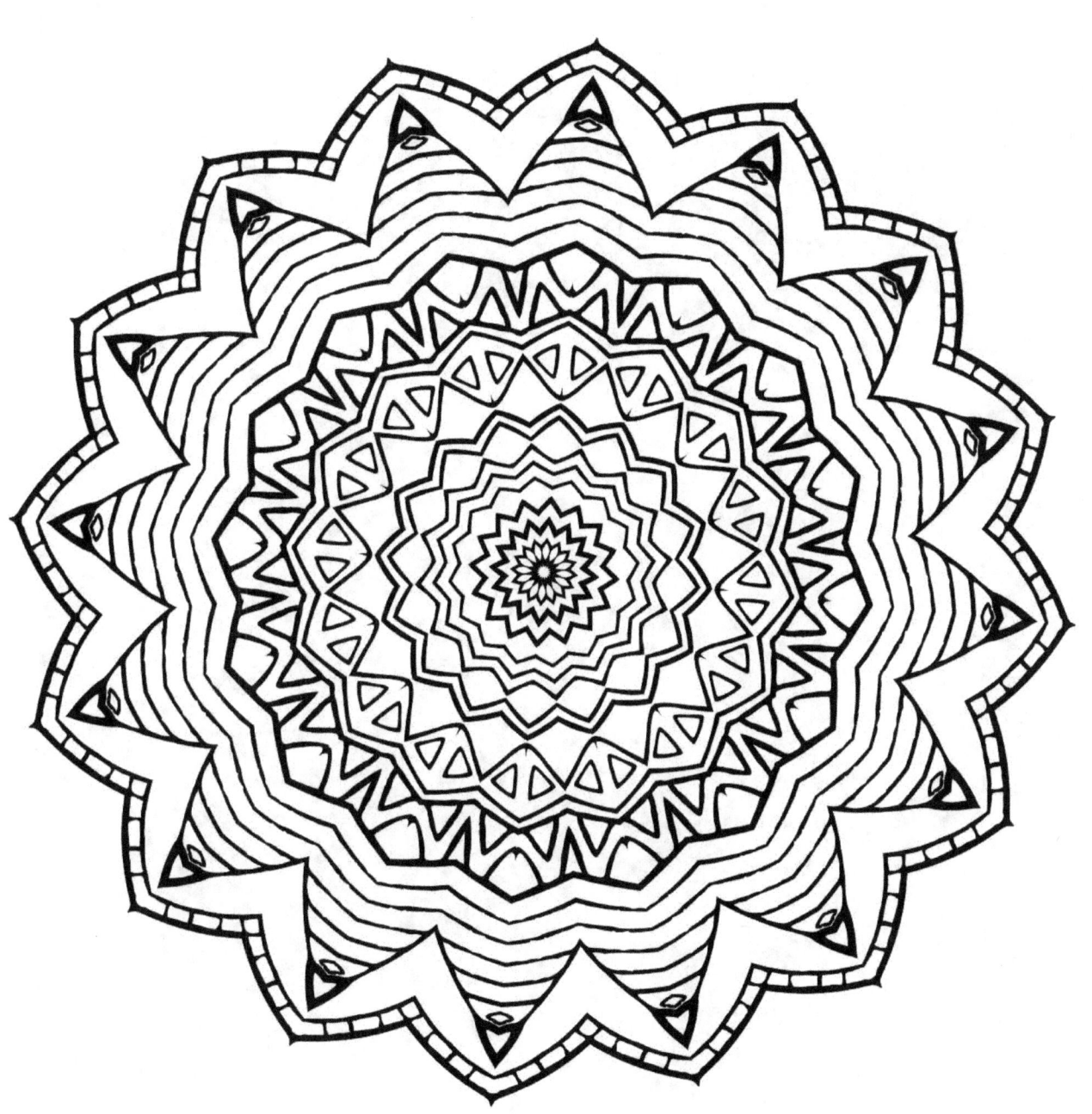

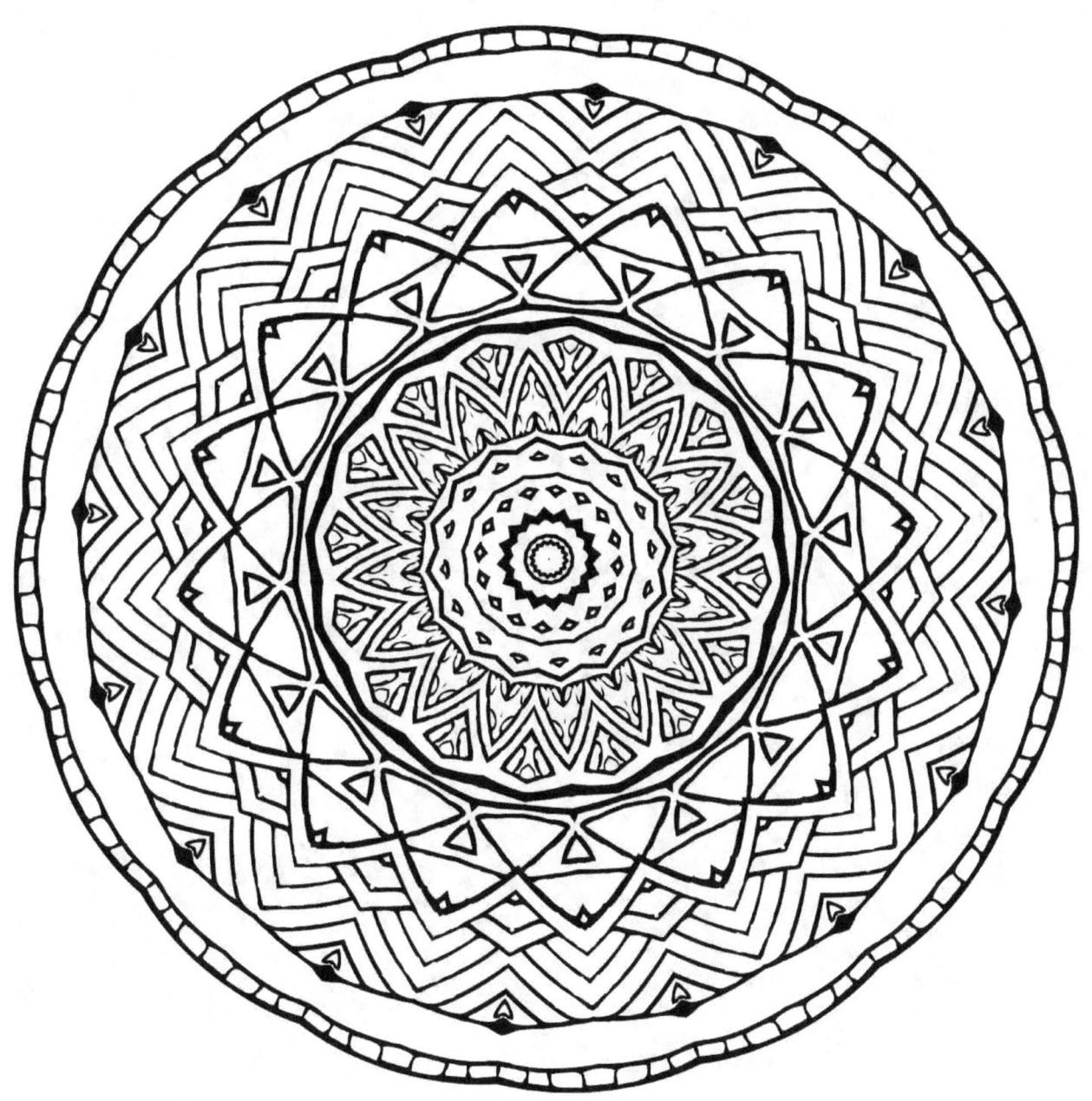

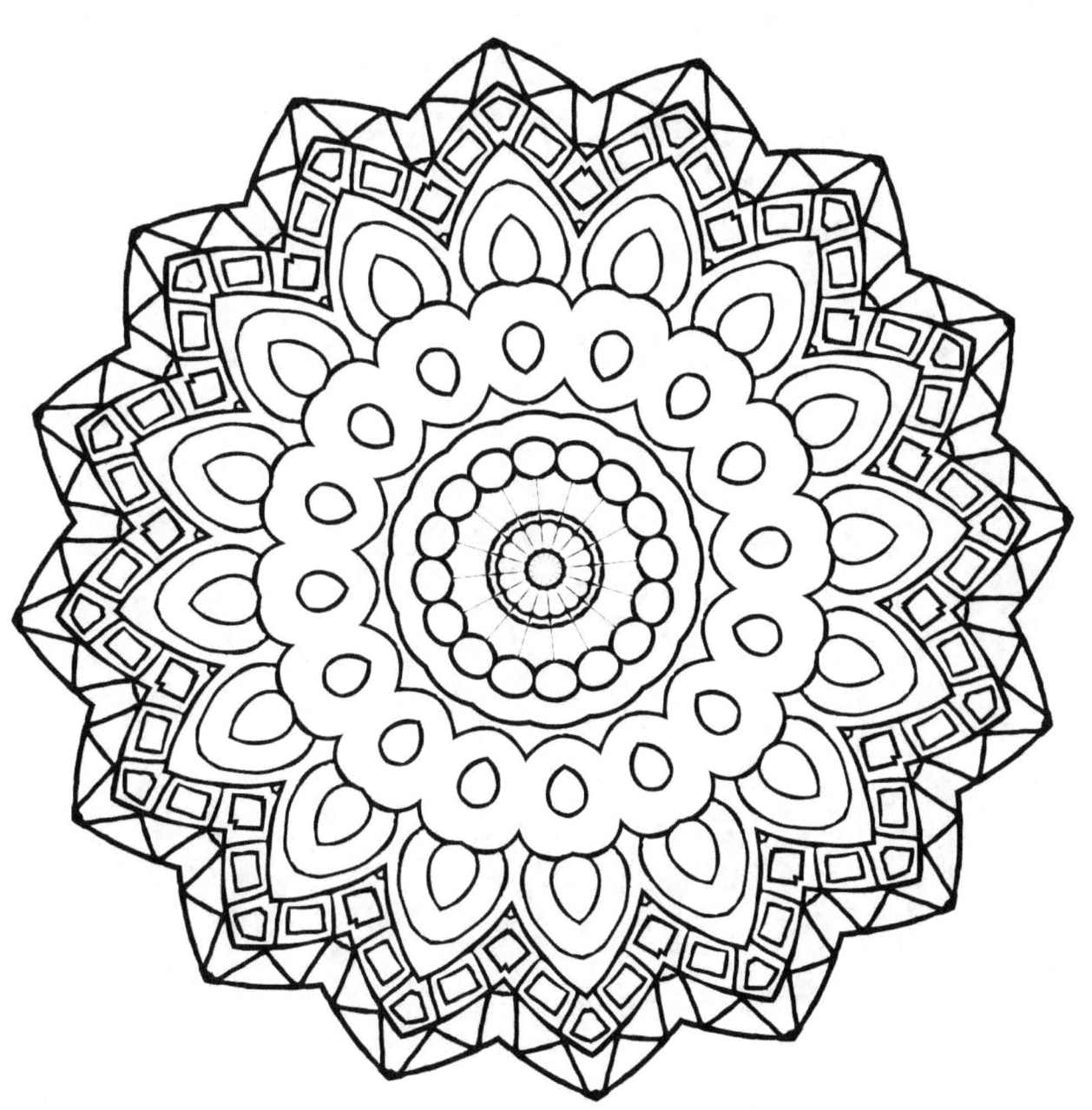

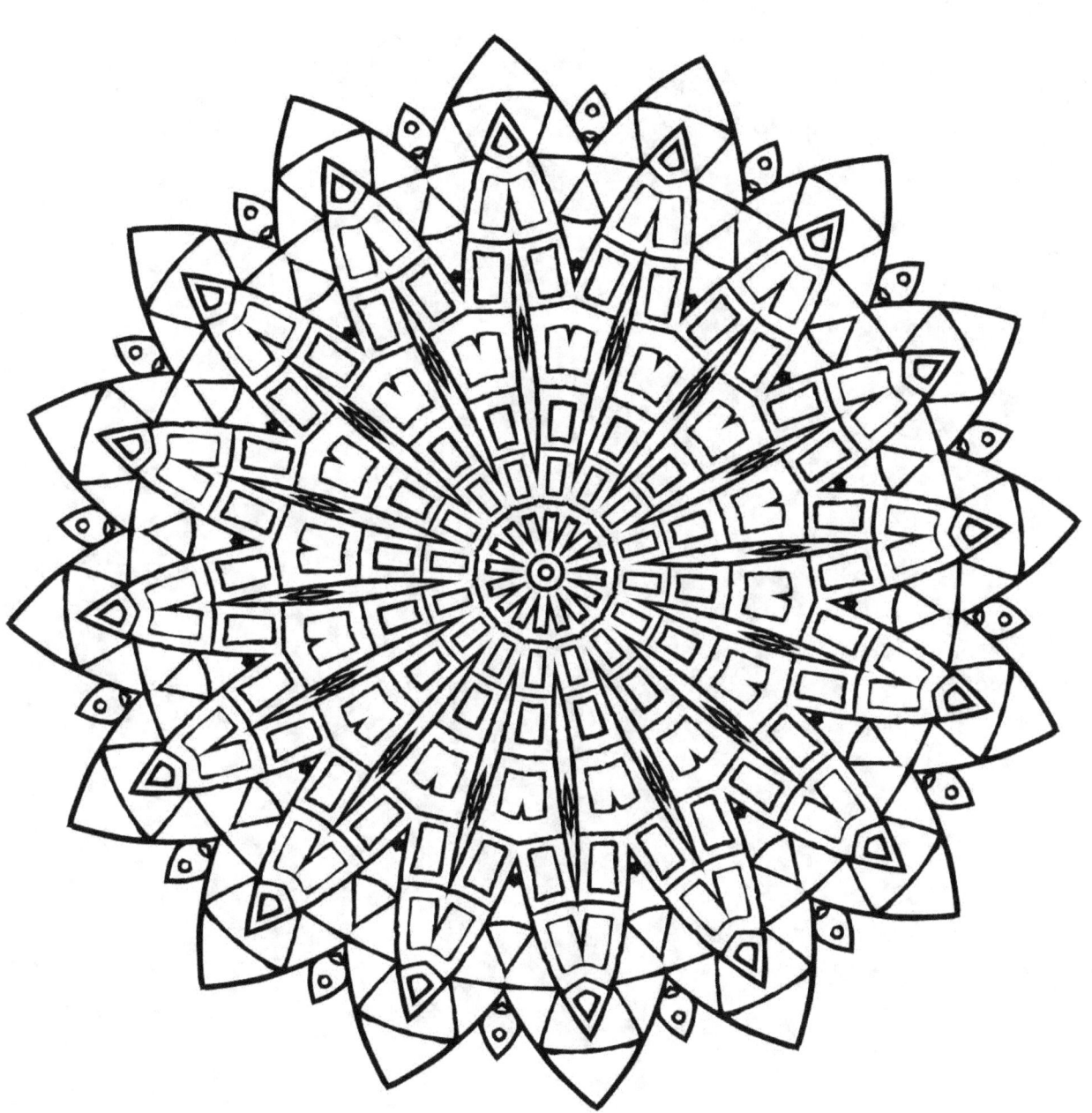

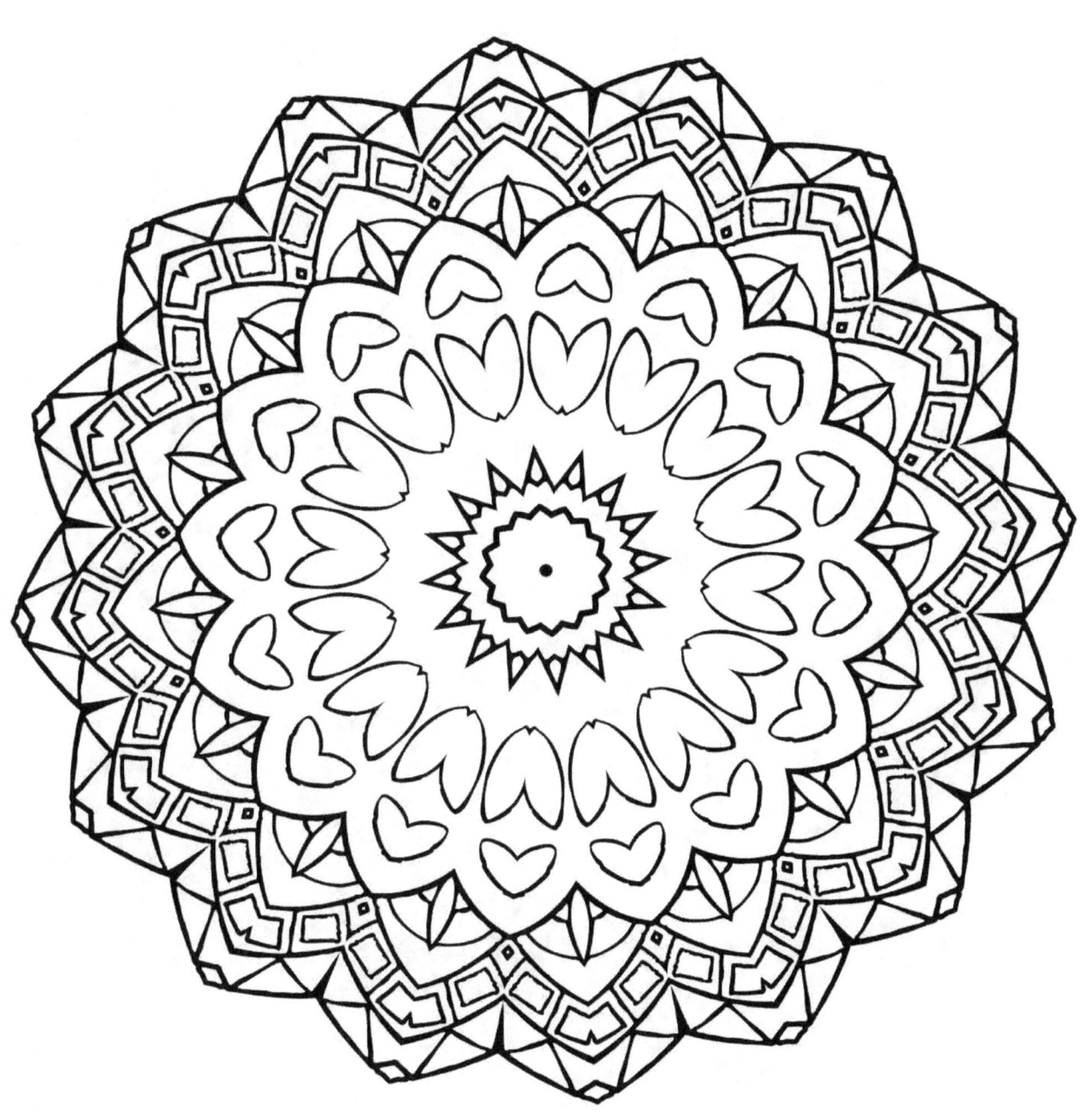

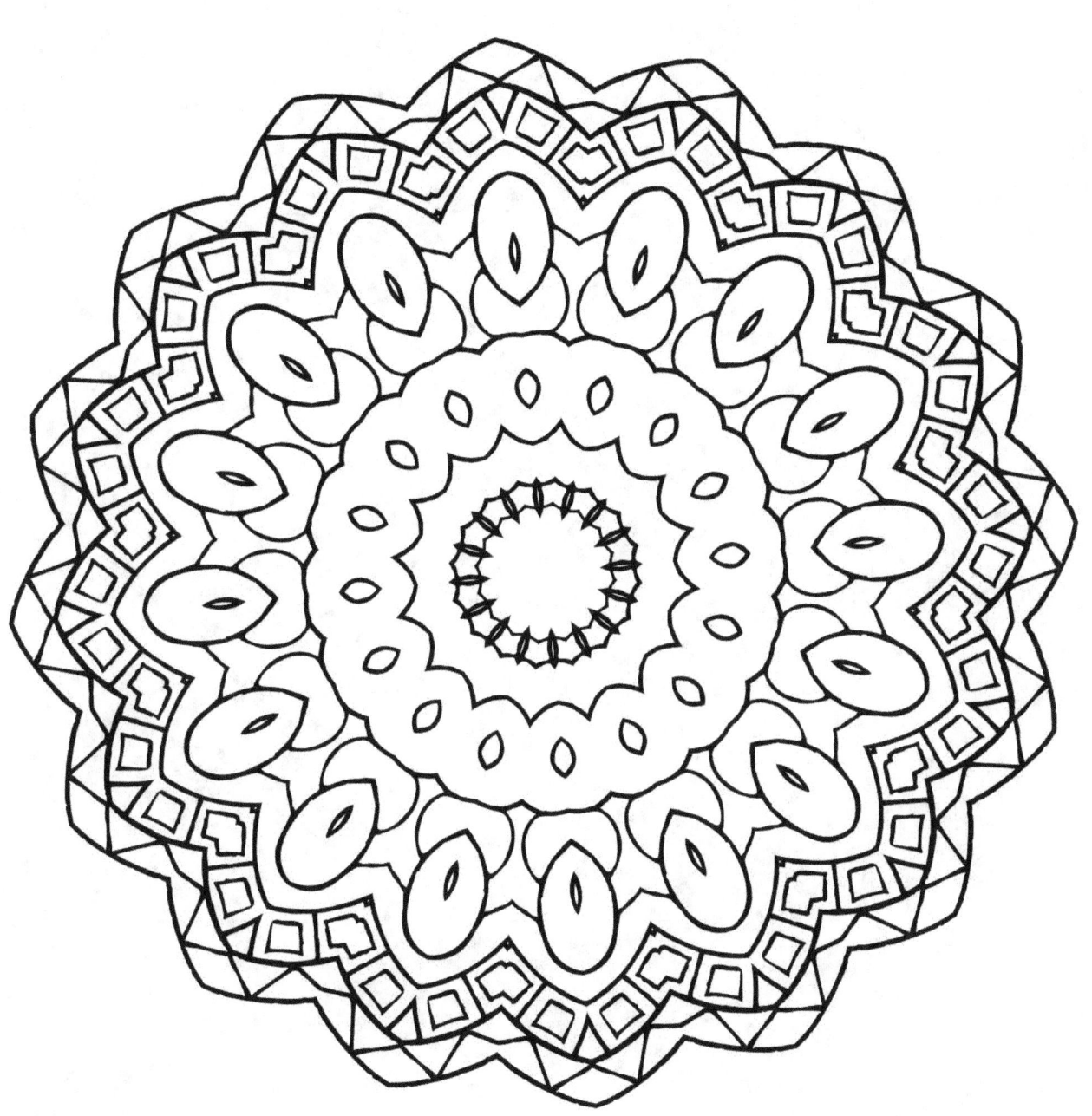

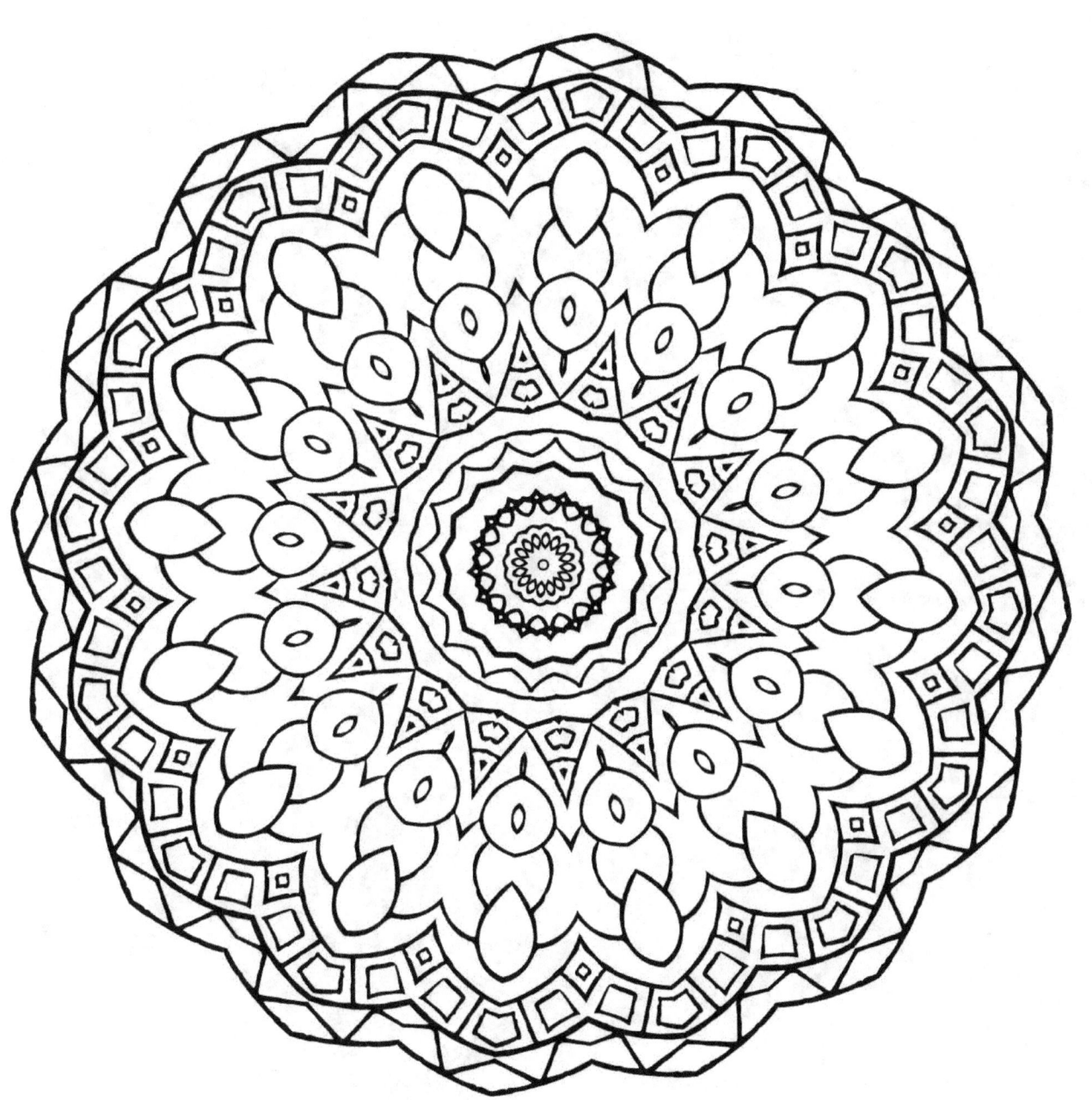

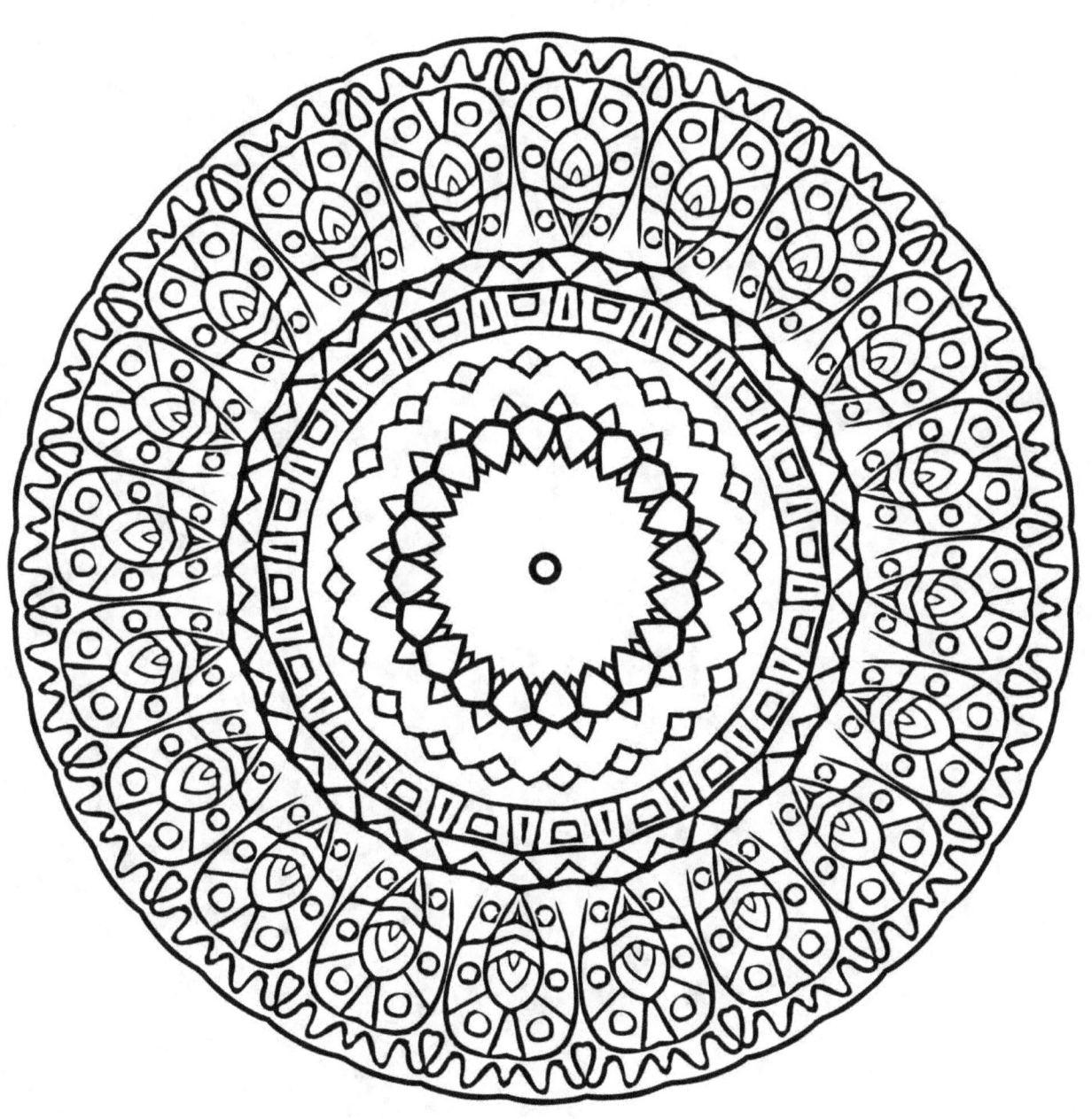

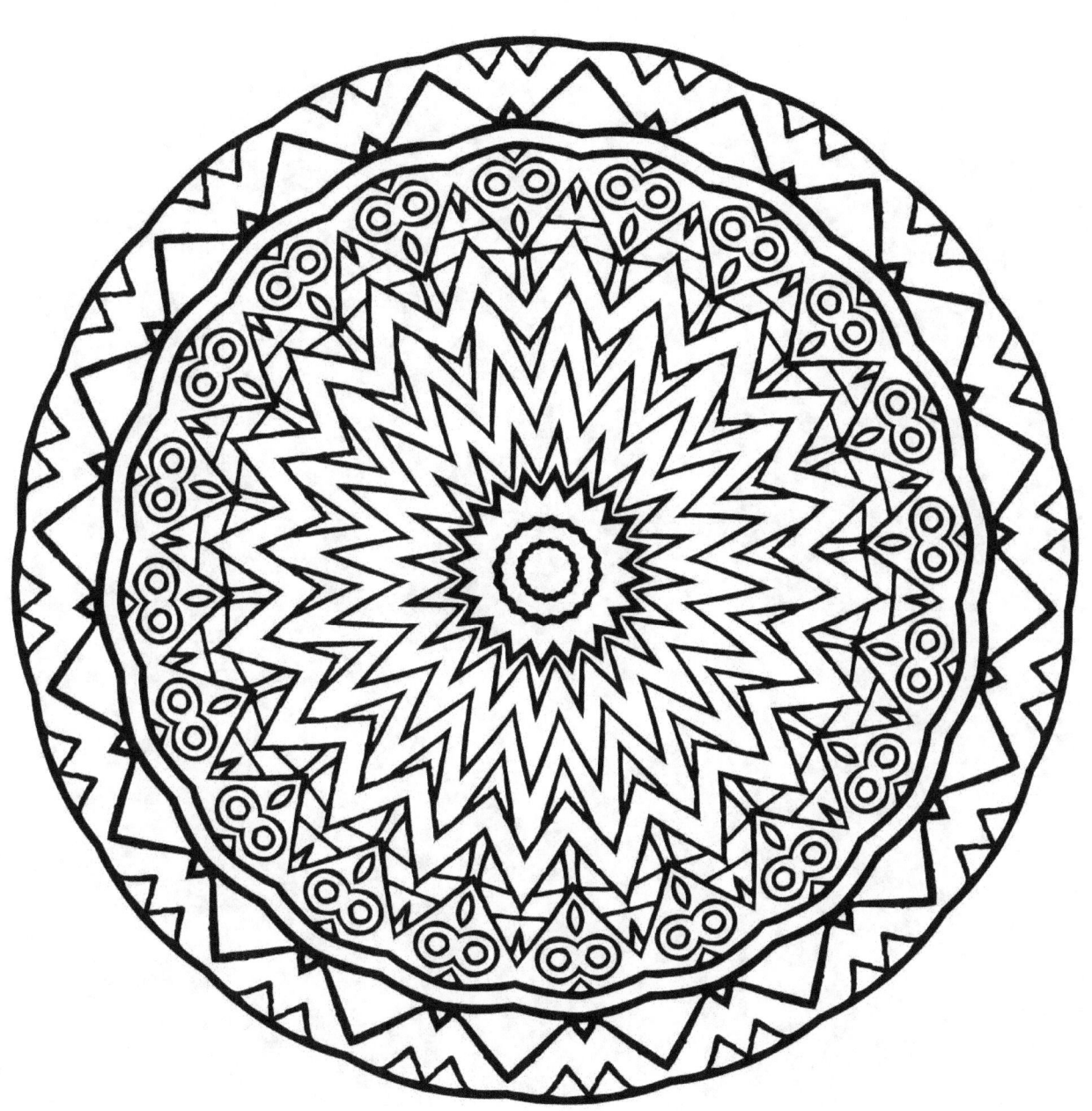

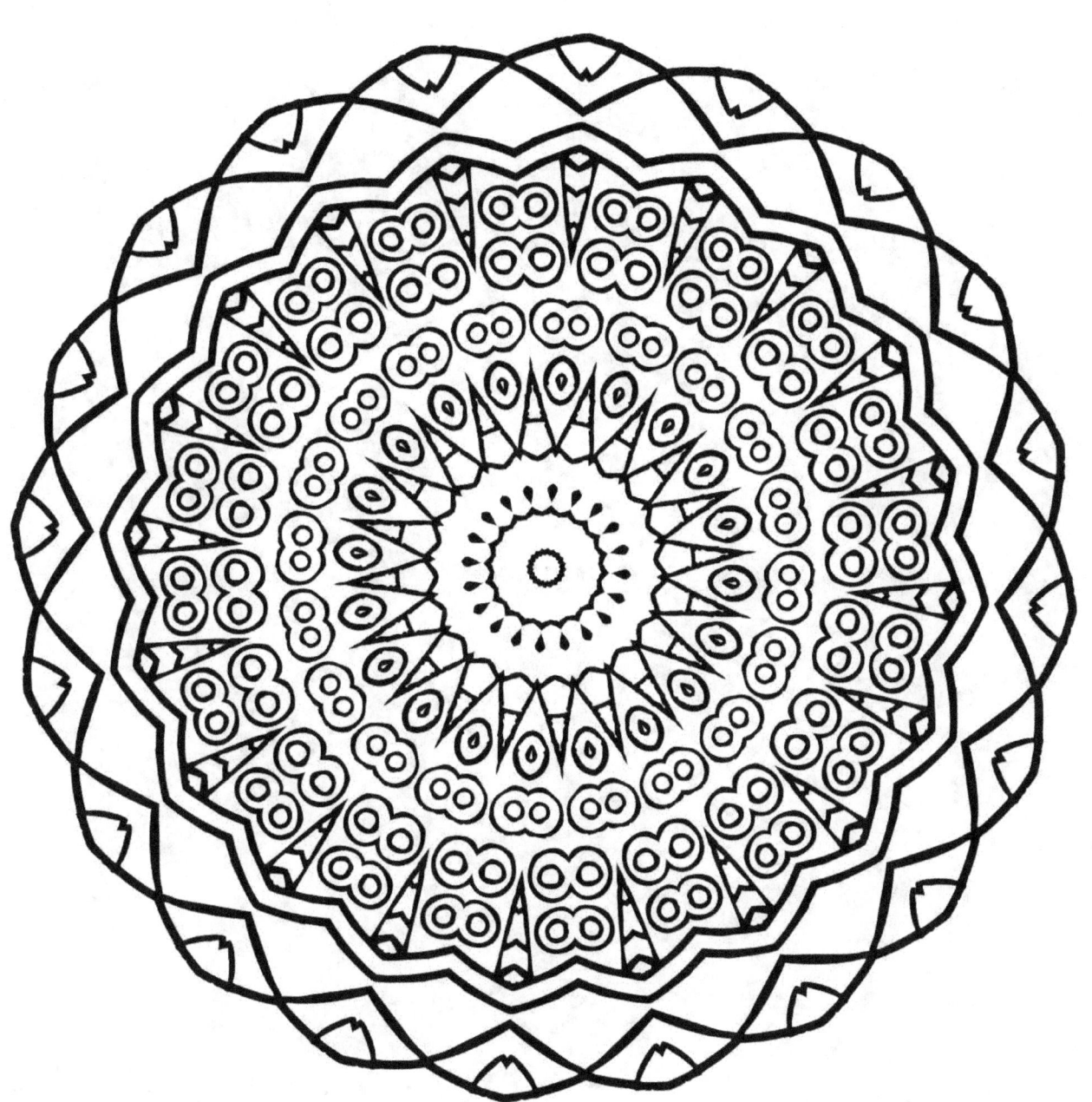

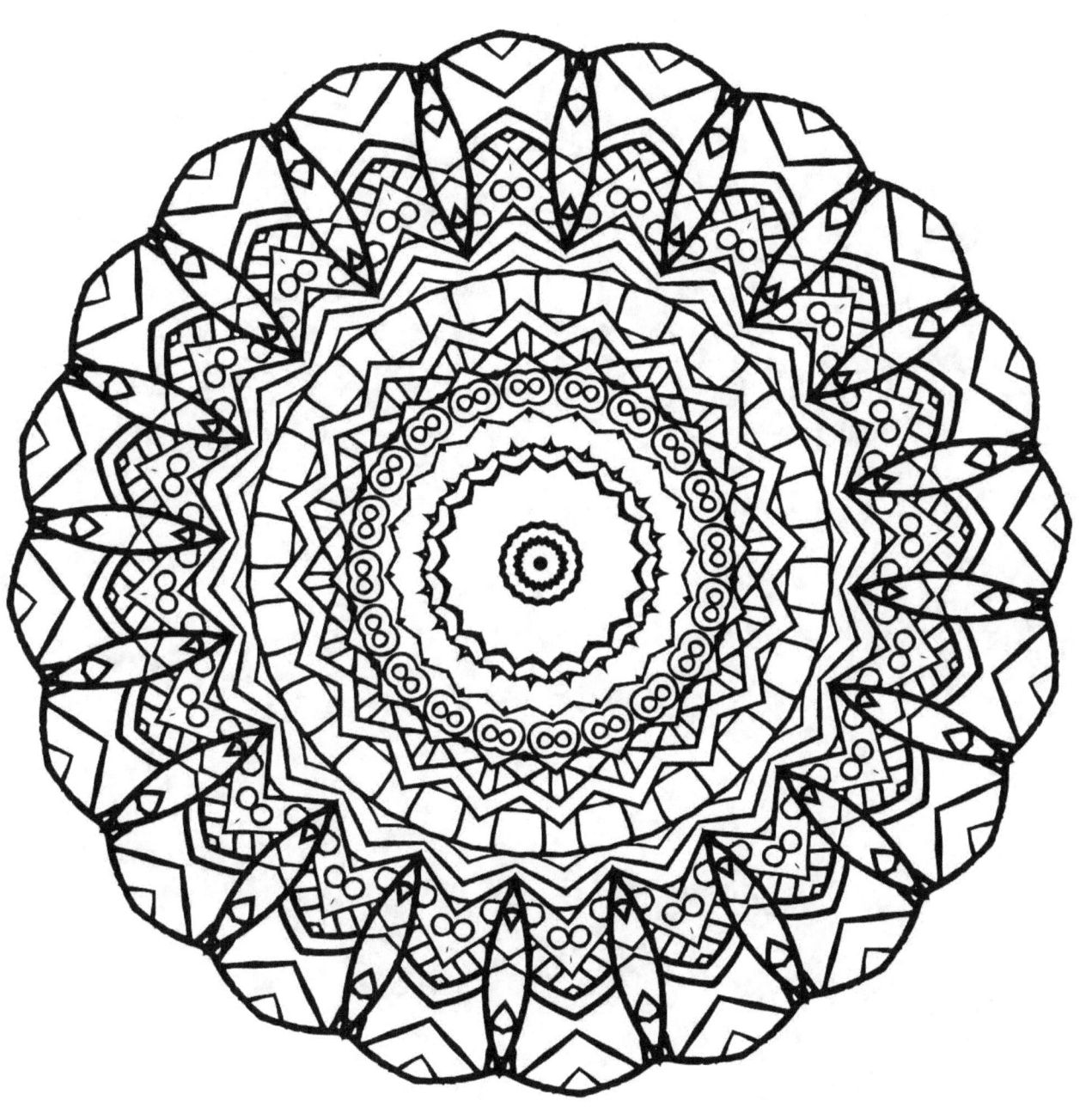

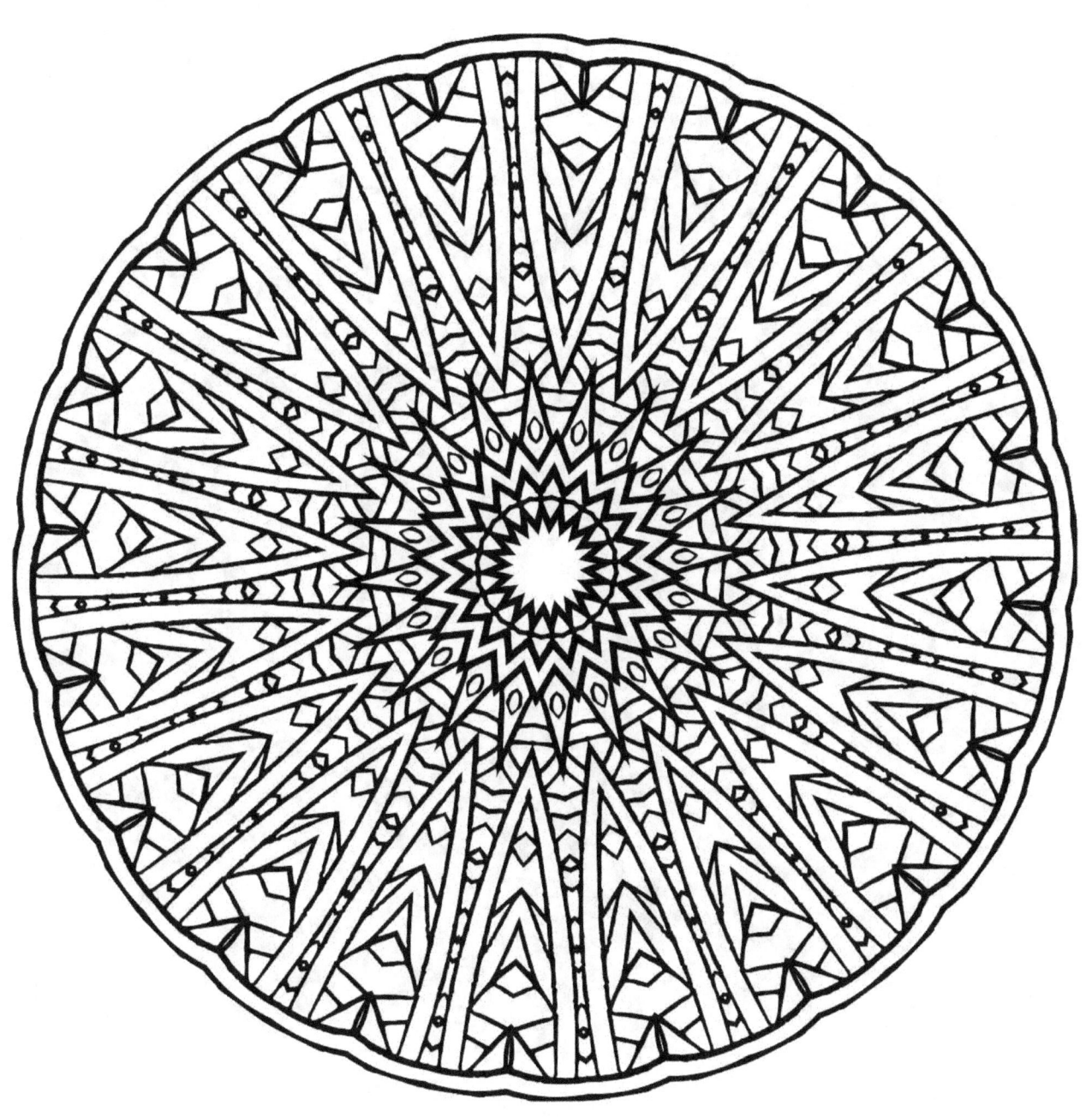

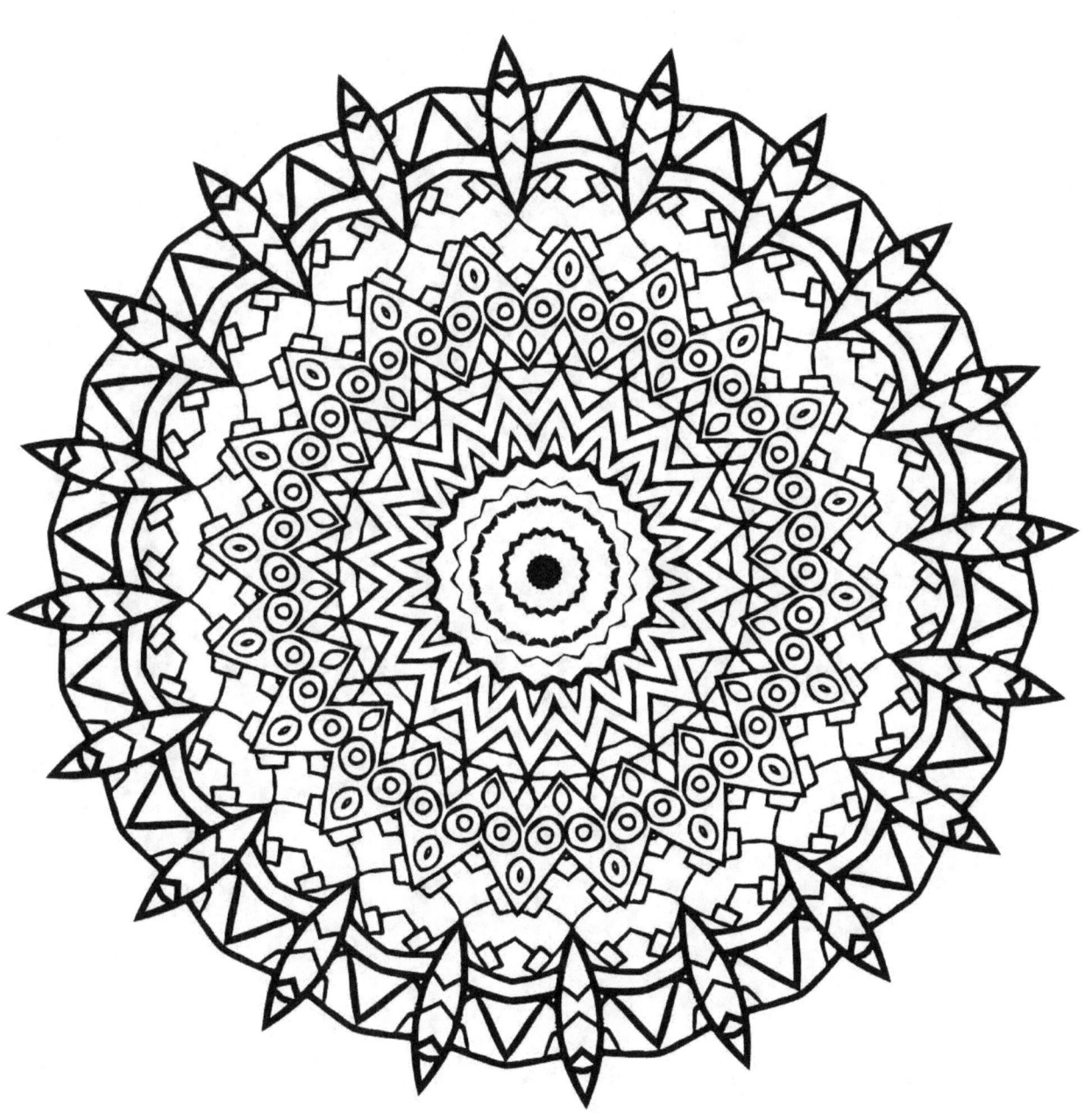

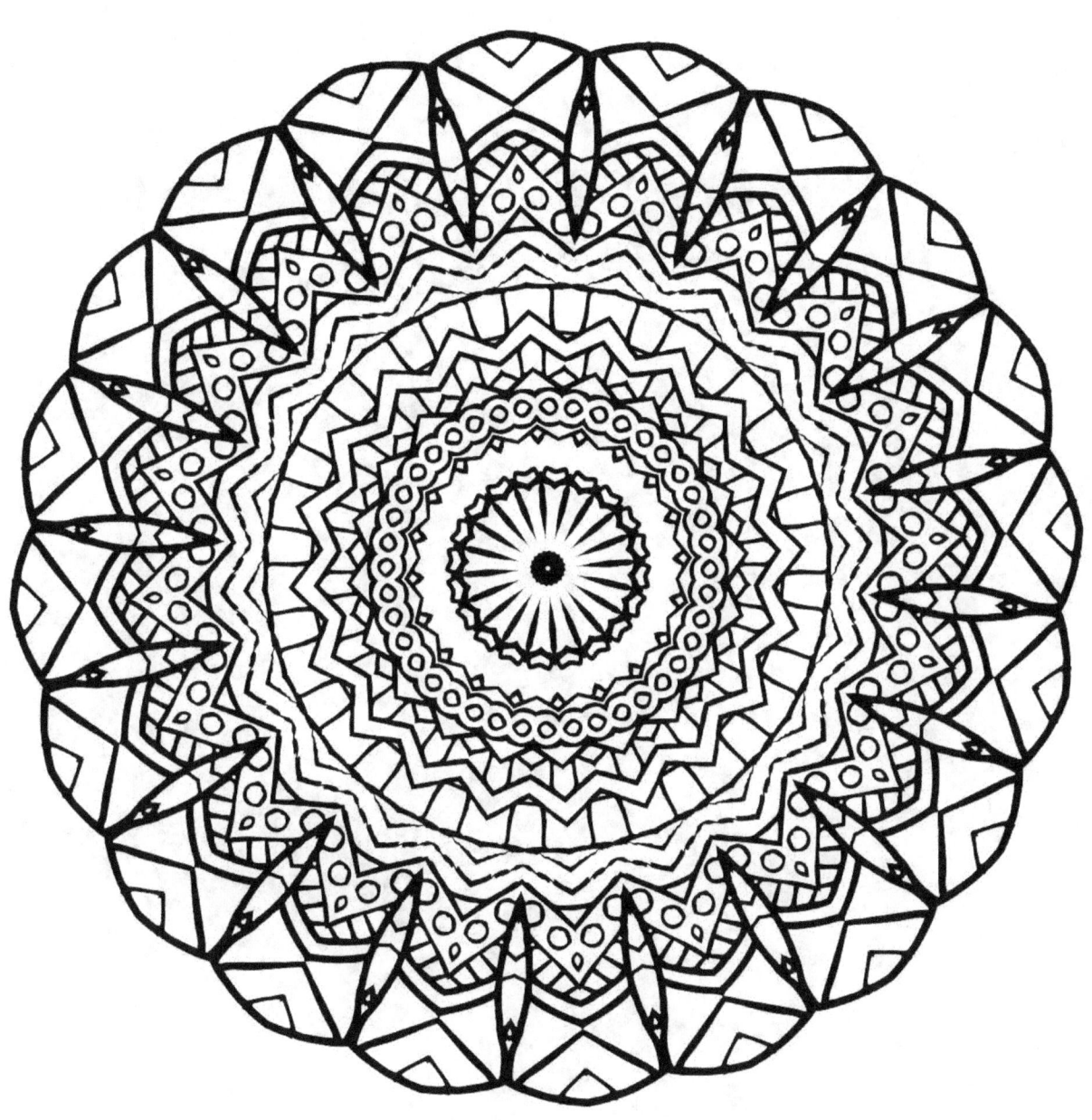

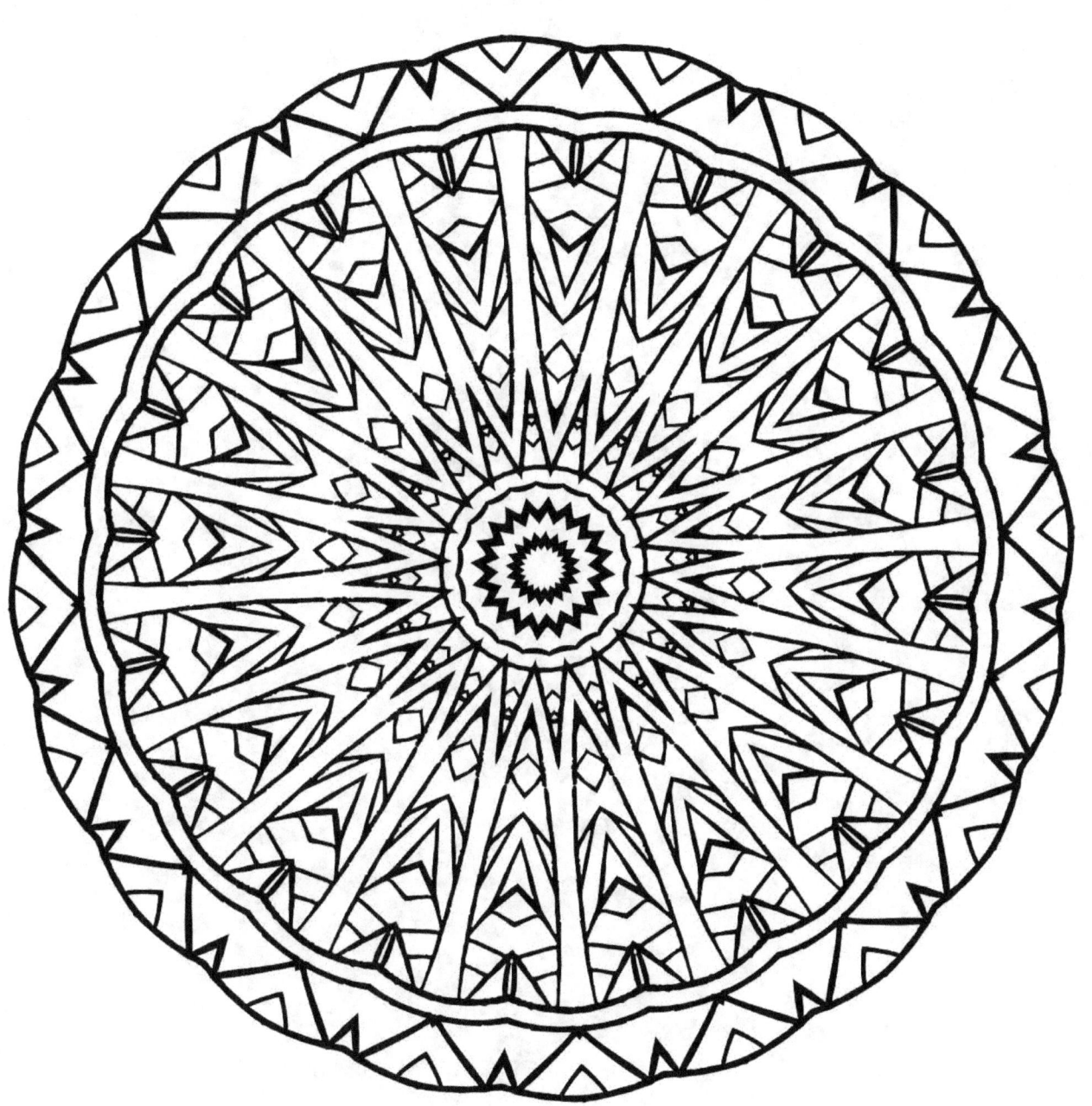

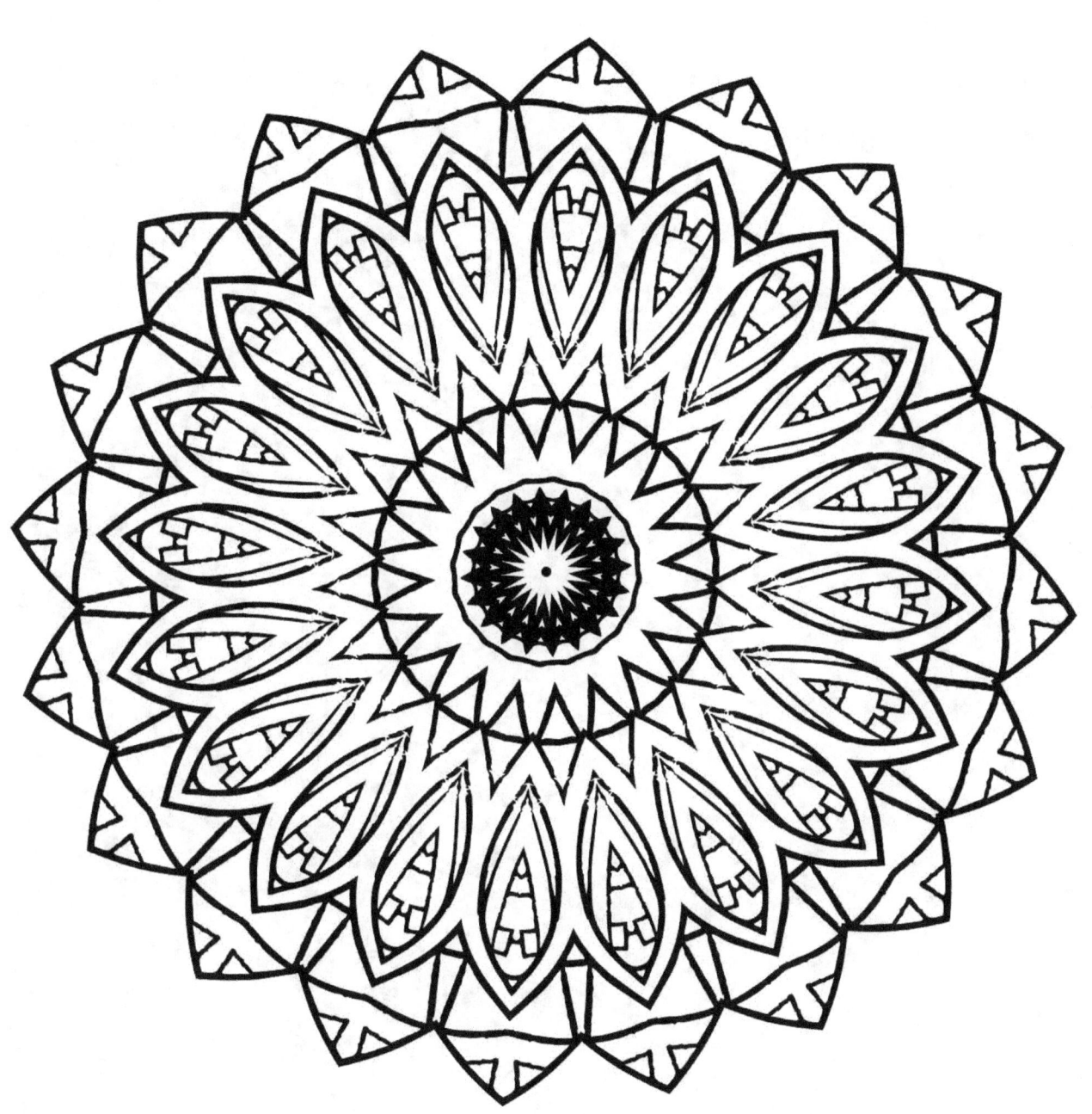

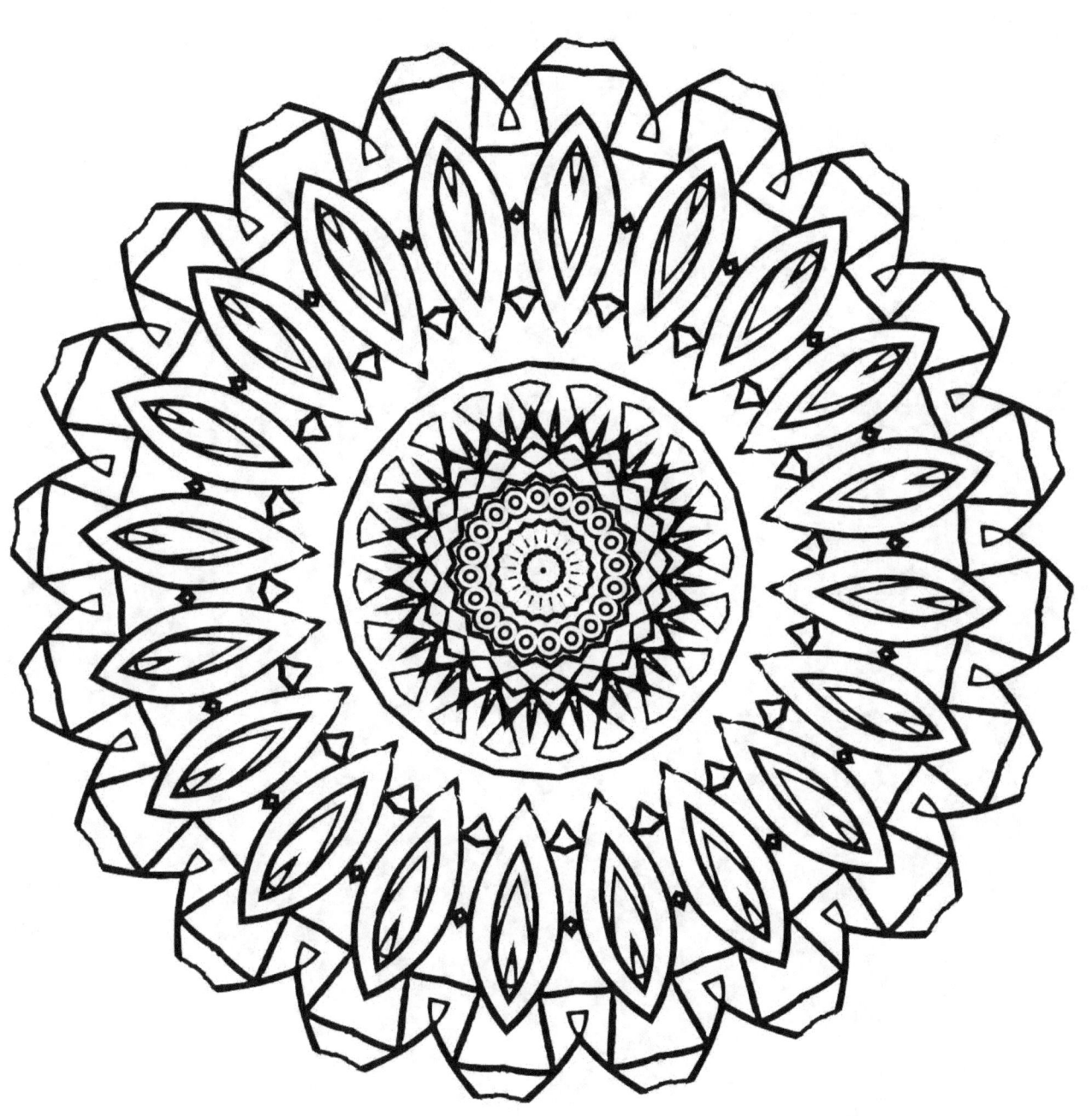

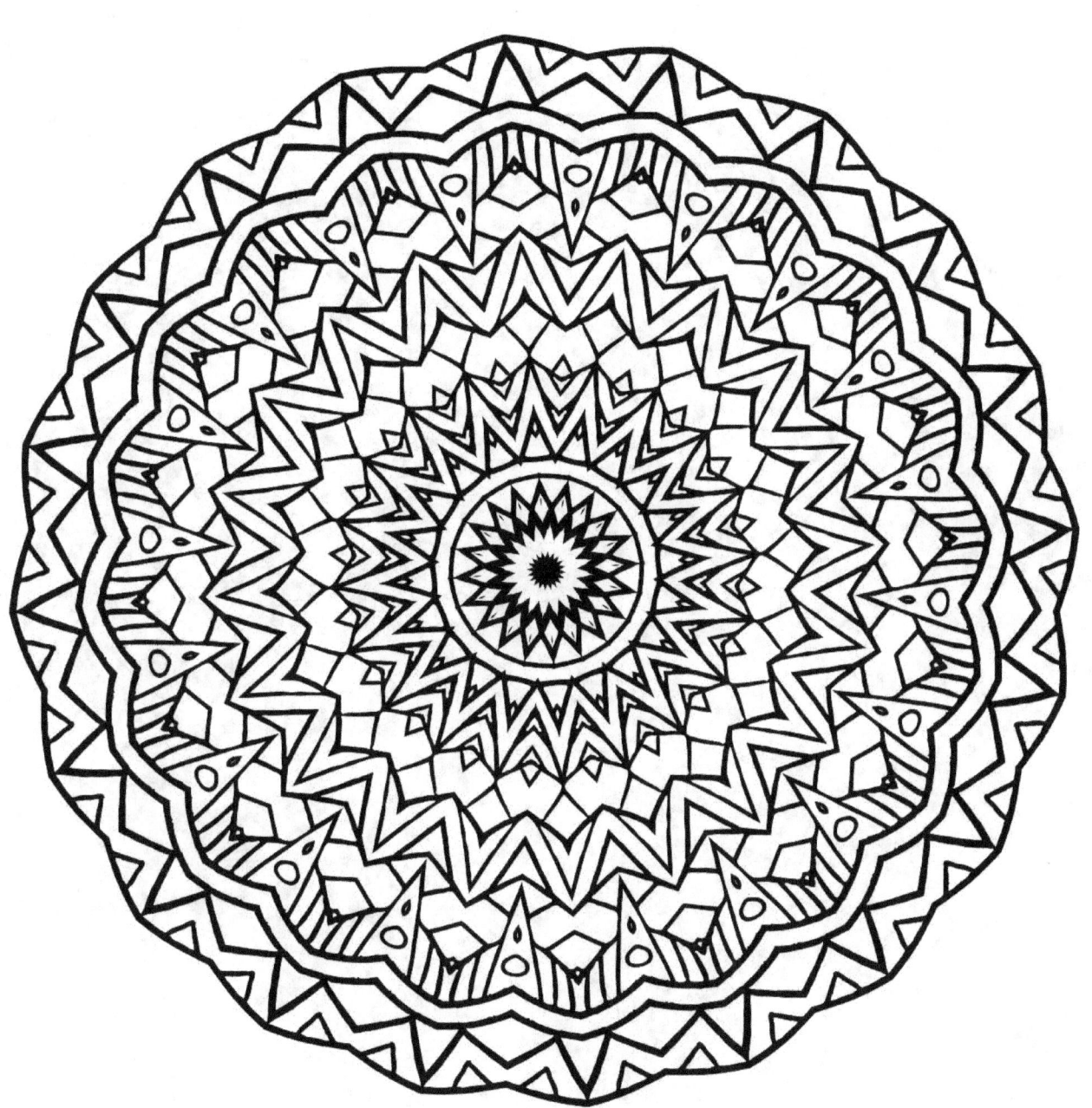

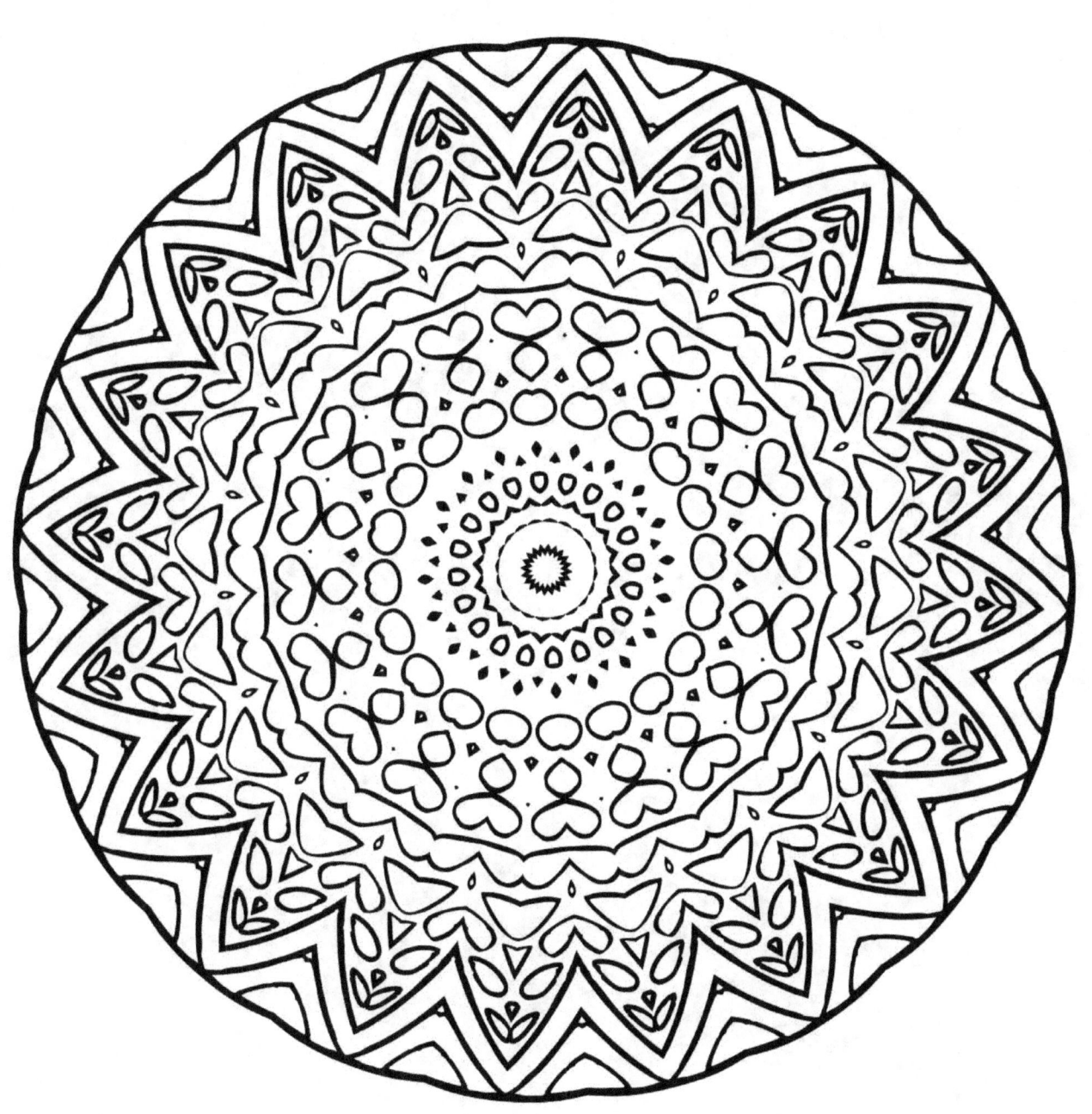

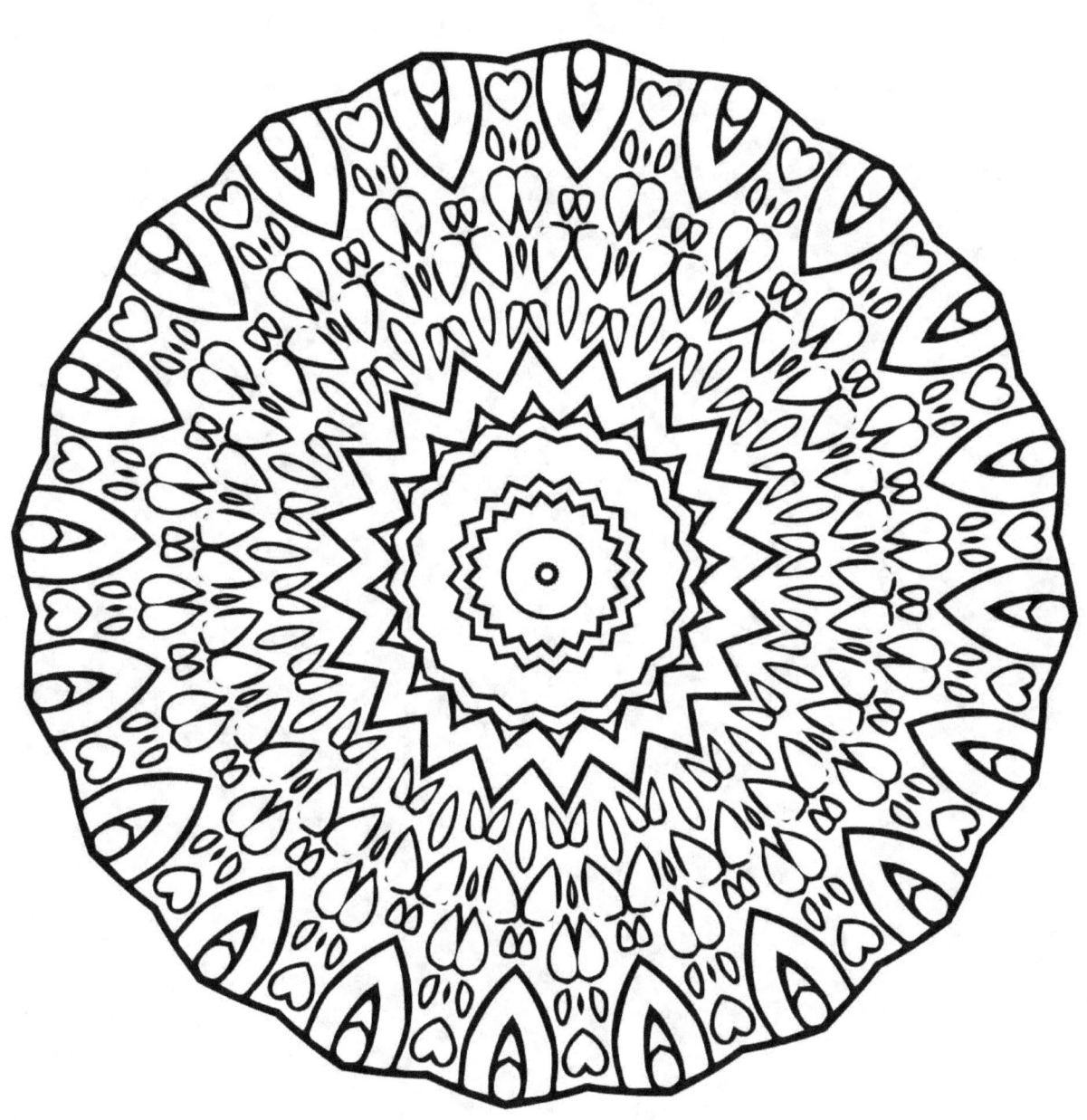

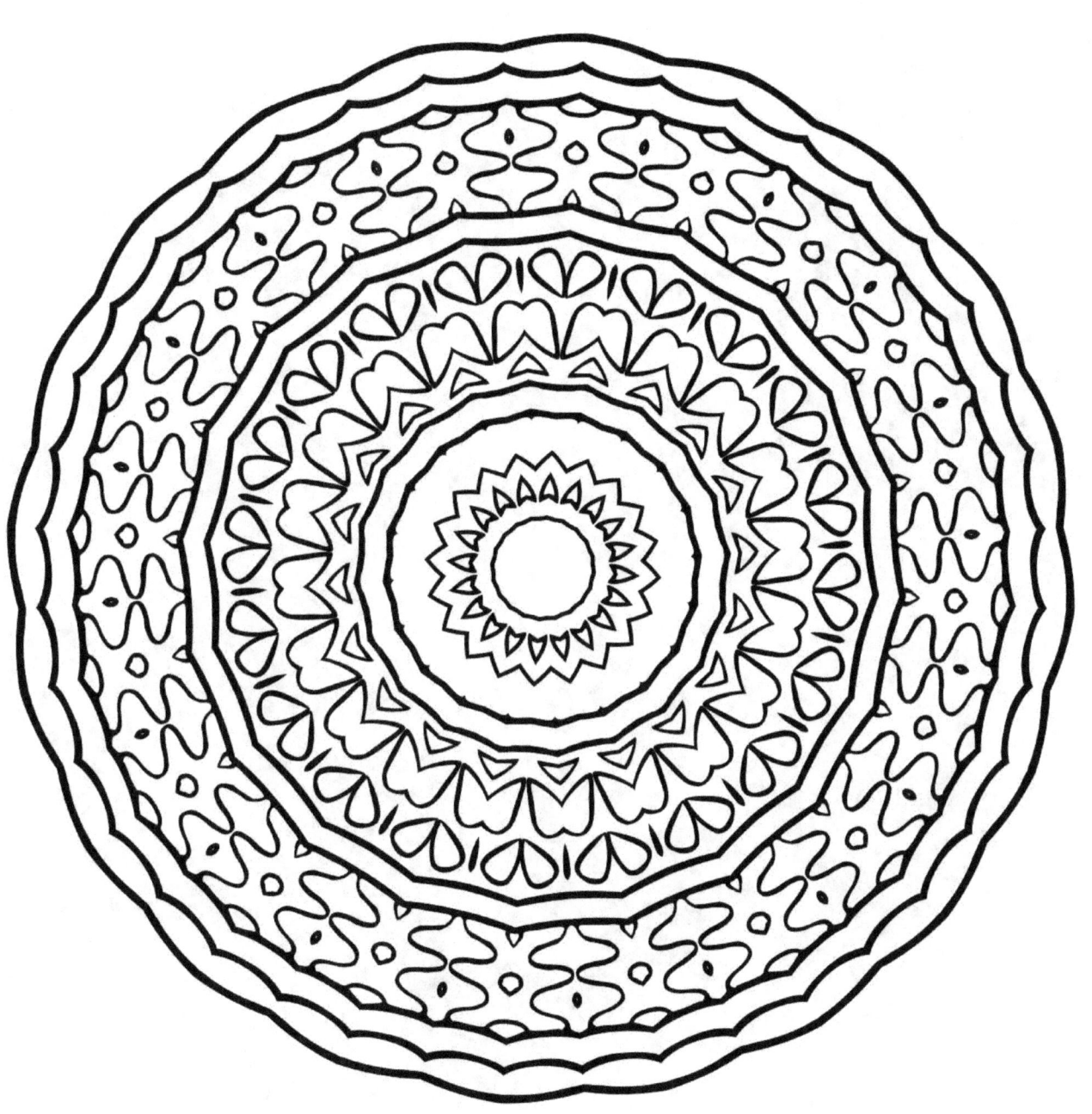

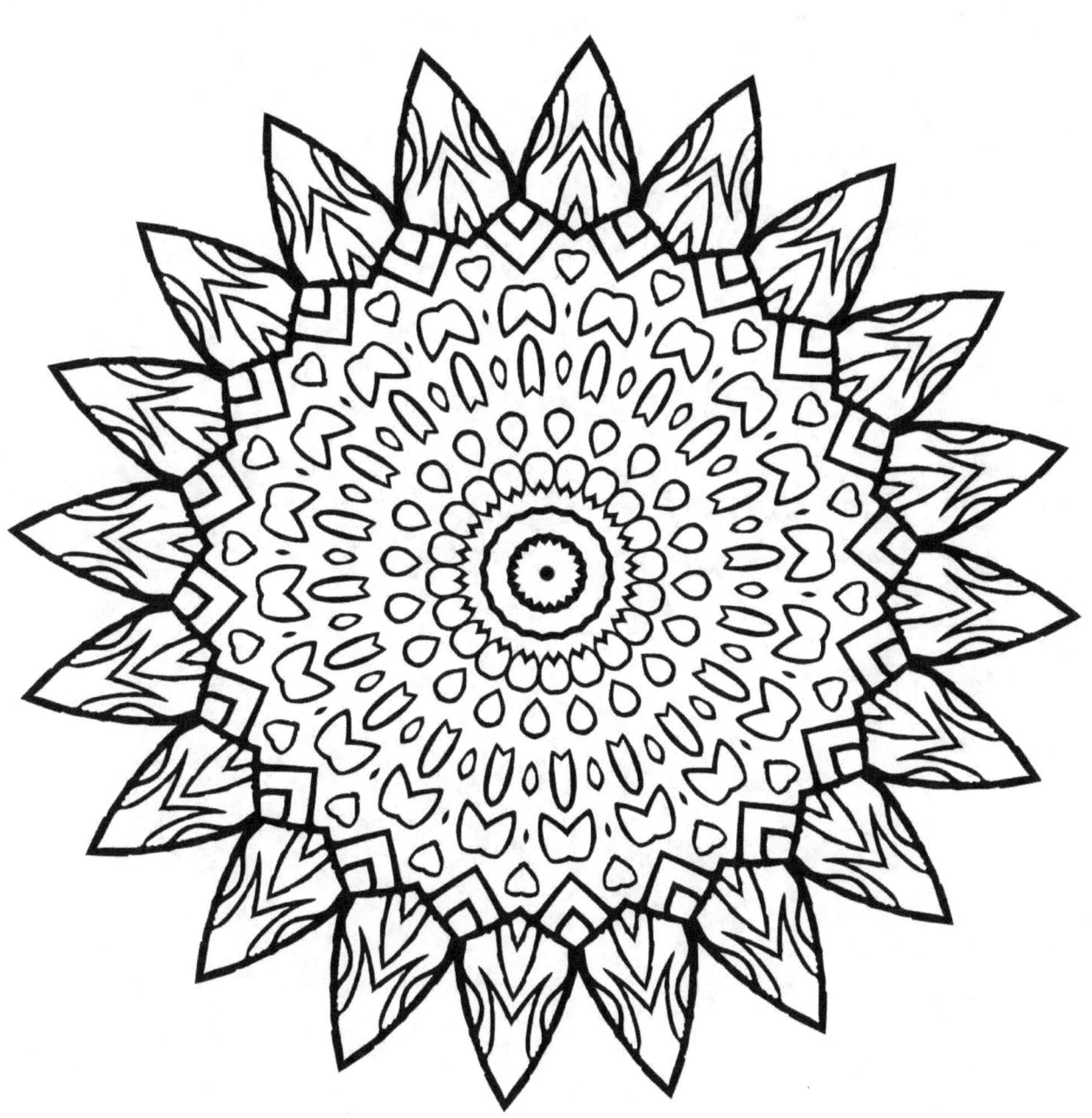

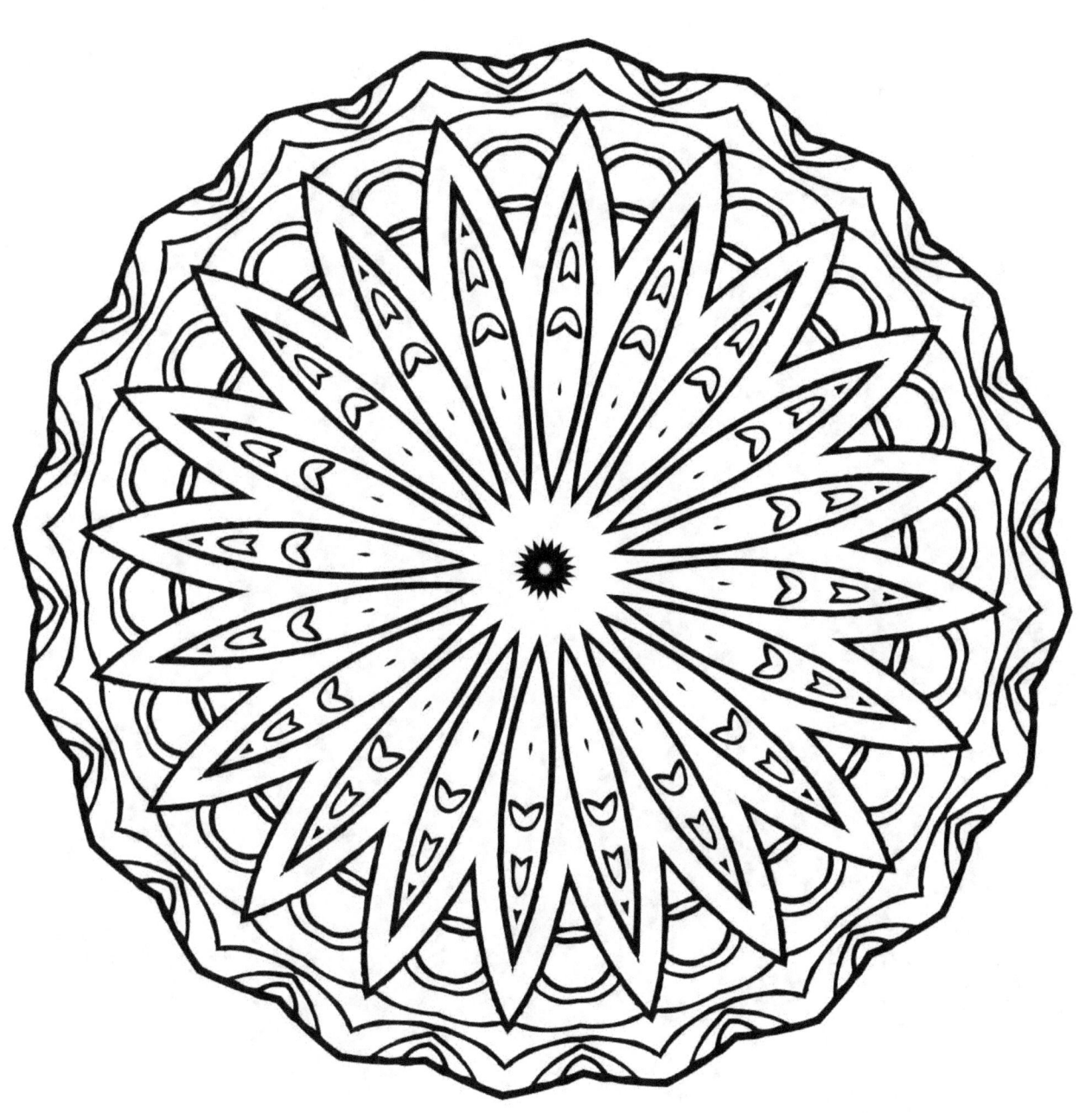

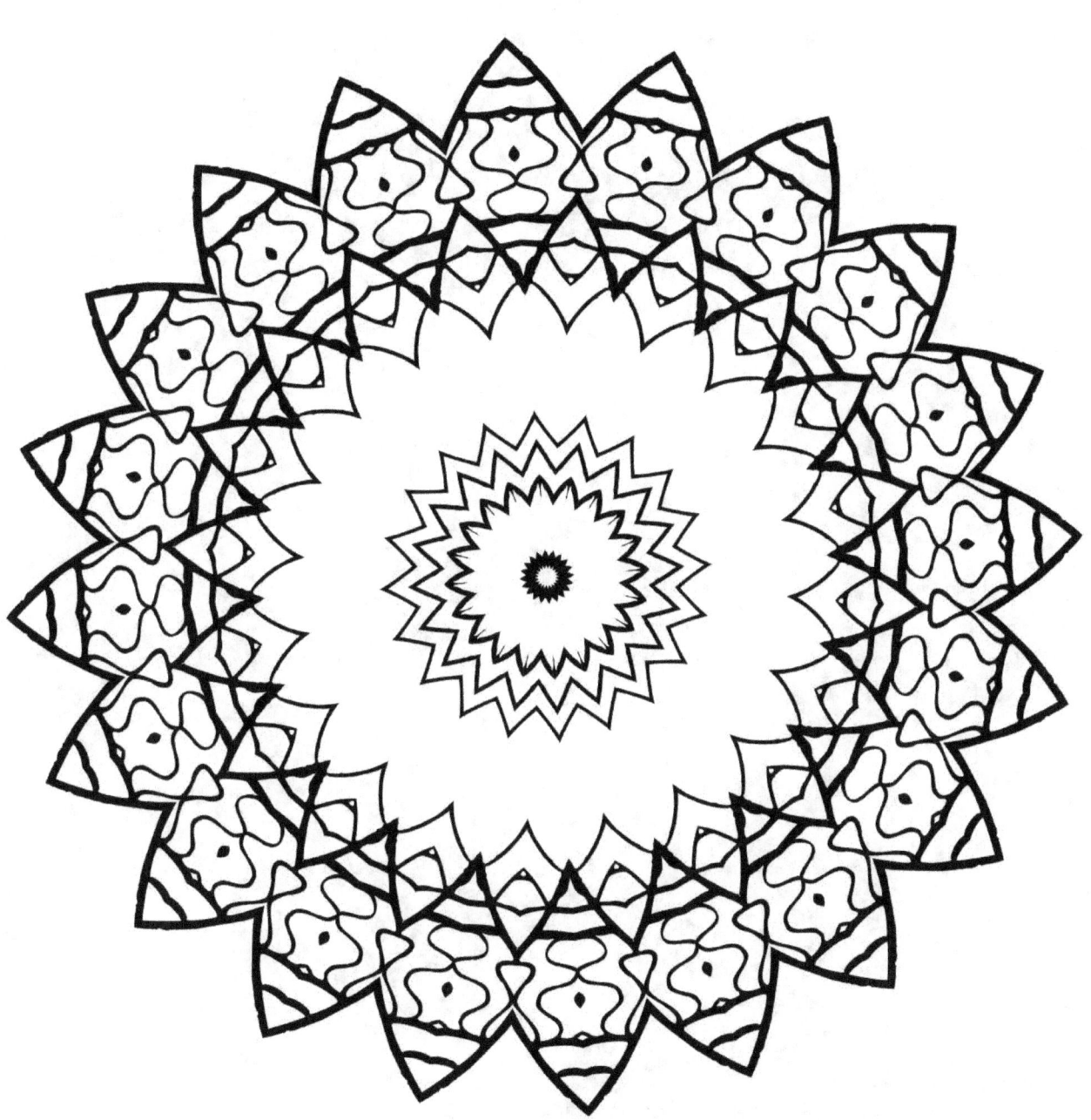

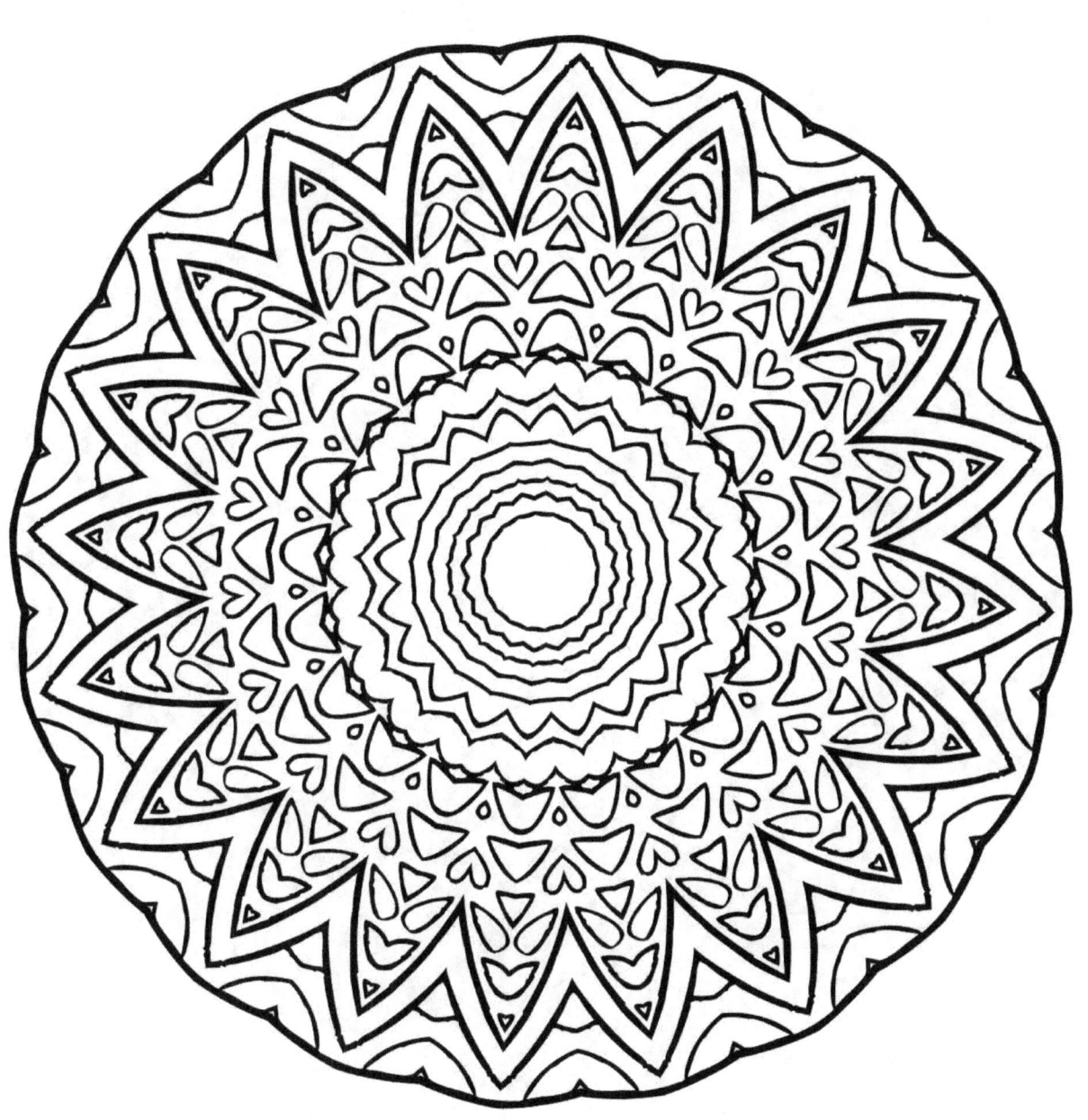

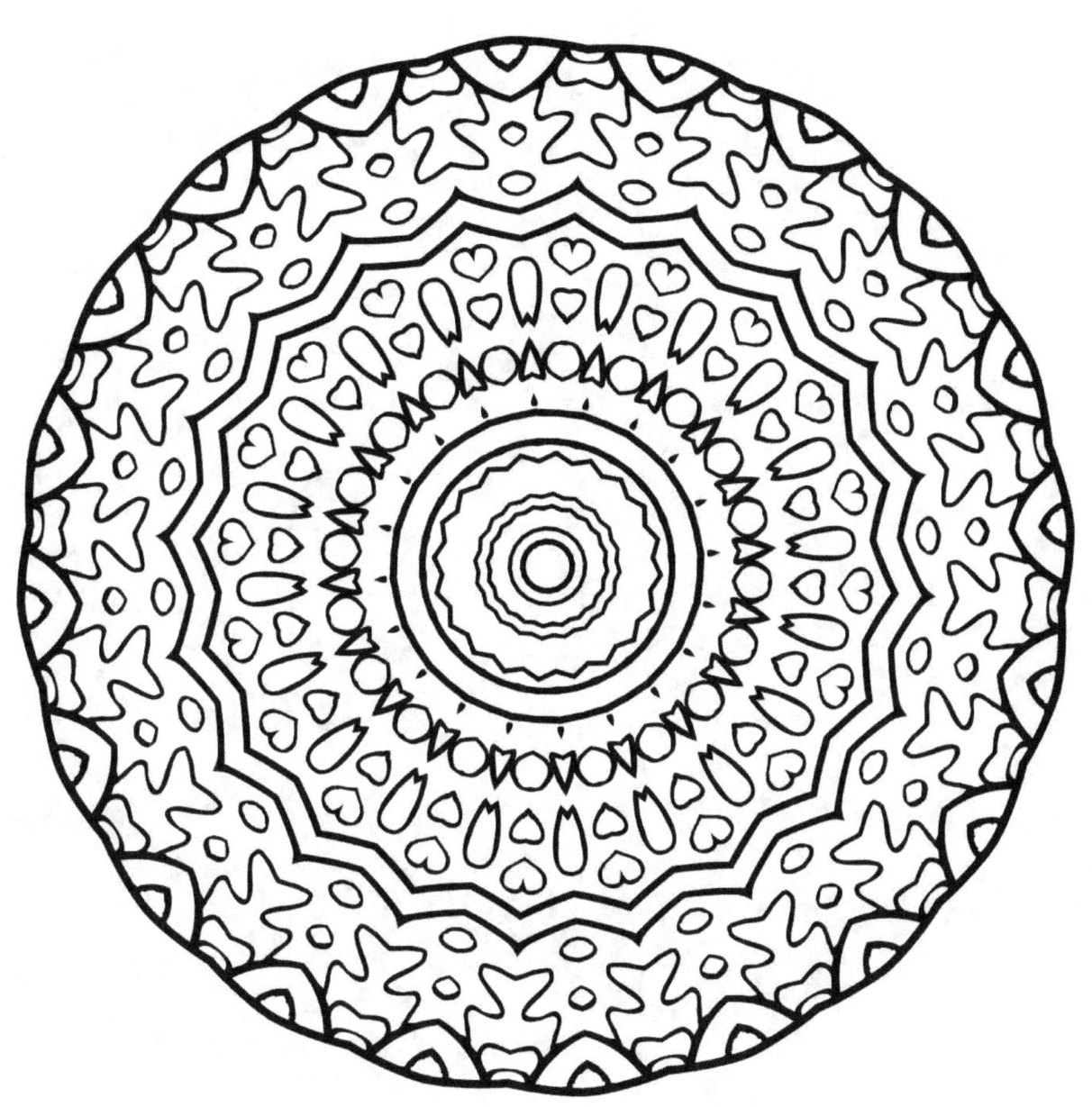